By WALTER LAUPPI

MOSAICS
with NATURAL STONES

⑤STERLING PUBLISHING CO., INC. NEW YORK

Oak Tree Press Co., Ltd. London & Sydney

OTHER BOOKS OF INTEREST

Aluminum and Copper Tooling
Ceramics by Slab
Colorful Glasscrafting
Crafting with Nature's Materials
Creating Silver Jewelry with Beads
Creative Claywork
Creative Enamelling & Jewelry-Making
Drafting Techniques for the Artist
Drawing from Nature
Embossing of Metal
Etching (and Other Intaglio Techniques)
Express Yourself in Drawing
Family Book of Crafts
Horseshoe-Nail Crafting
Junk Sculpture
Leathercrafting
Lithographic Prints from Stone & Plate

Make Your Own Elegant Jewelry
Make Your Own Rings & Other Things
Making Mosaics
Making Picture Frames
Metal and Wire Sculpture
Nail Sculpture
Pebble Collecting and Polishing
Practical Encyclopedia of Crafts
Prints—from Linoblocks and Woodcuts
Screen Printing
Scrimshaw
Sculpture for Beginners
Sculpturing with Wax
Stained Glass Crafting
Starting with Stained Glass
Stone Grinding and Polishing
Tin-Can Crafting

Whittling and Wood Carving

Translated by Manly Banister
Adapted by Burton Hobson

Contents

About Stones

For the mosaic craftsman-artist (called a mosaicist), there are two paths to obtaining raw materials—one easy but costly, the other requiring more effort but also more rewarding. The easy way is simply to buy ready-made mosaic glass or ceramic tiles (tesserae) that come in a wide variety of uniform colors in standardized squares or cakes. These prefabricated pieces do have the advantage of being easily purchased and time-saving in their application. They have certain disadvantages as well, even beyond their comparatively high price. In general, these manufactured tiles are vividly colored. Since the amateur craftsman is likely to afford only a limited palette of colors, the lack of sufficient tones and shades often leads to jolting contrasts. Taken individually, these tiles are attractive enough but they cannot escape their assembly-line aspect. Their surfaces are uniformly slick, their polish impeccable, but their inner character is impersonal and cold. A mosaic constructed of these synthetic materials seems trite and commonplace. On the other hand, if you invest the time

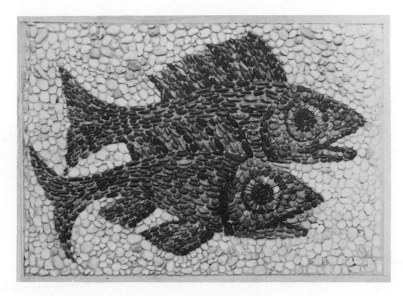

This mosaic of two sprightly fish was made entirely from uncut natural stones.

and trouble to gather natural stones yourself, and each one has a small adventure of search and discovery behind it, your feeling about a finished work will be quite the opposite. After a period of hard, manual labor in the school of natural stones, you will develop a relationship to the material and soon gain mastery over every aspect of the craft.

The search for natural stones will lead you into hills and valleys, along seacoasts and stream beds, into fields and woods. After every trip, admiring the beauties of nature as well as searching, you will be tired, but tired in a delightful, healthy way. It is a harvest that not only puts stones in your bag but also sun in your face, rain on your neck and peace in your spirit.

Natural Stones

Naturally occurring stones provide a "palette" of thousands of shades of color with the single exception of blue. Ordinary pebbles are found in the beds of streams where they flow into rivers (the farther from the source, the richer and more polished the material), stony fields, gravelled roads, construction sites, at the bottom of caves, in cliffs and, of course, on beaches. Carry a hammer with you to knock the edge off promising looking specimens to reveal the inside color which otherwise would not show up as being different from the outside until you carry them home. Be sure to obtain permission before gathering stones from private areas.

Oval-shaped pebbles such as these are easiest to split. Marble and limestone slabs can be split easily into cubes or squares.

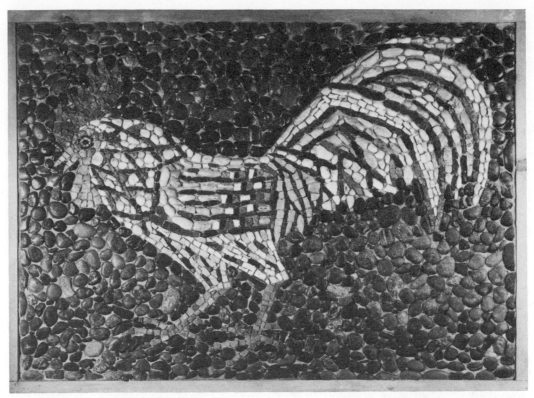

This proud rooster (shown in full color on the front cover) was created from an assortment of halved stones and split and squared pieces as well as stones left in their natural state.

Quarry Stone

If the quarry owner will allow you to gather stones yourself, avoid chunks. Gather workable, flat pieces if you need a large quantity of a single color. Here also you need to break off oxidized pieces with your hammer to reveal the true color.

Marble and Limestone

These can be purchased in slabs from stone cutters and marble works. The so-called blue marble is often available. This is a bluish-grey, crystalline limestone, which goes well with yellow and brown stones. Masonry supply dealers often carry a variety of other stones in stock as well.

Gem Stones

The color blue is found among gem stones. Lapis lazuli from the mines of Andes de Ovalle in Chile possesses a wonderfully flecked cobalt blue (deep sky-blue); Persian lapis is a mysterious, dark ultramarine (violet-blue). Aragonite, thulite, zoisite, epidote, azurite, verdite, nephrite, rhodonite, rhodochrosite, serpentine, malachite, and hard quartz such as aventurine, tiger's-eye, hawk's-eye (a blue variety of tiger's-eye), flint,

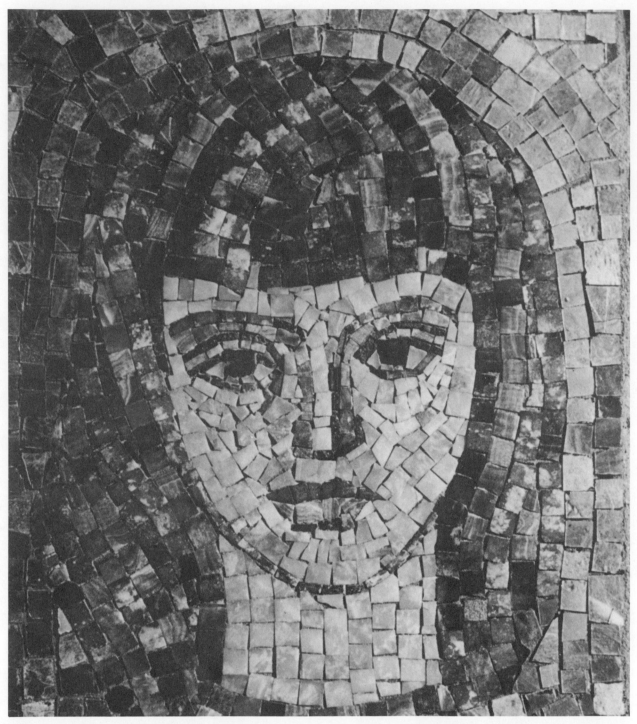

This gem-stone mosaic of a child's head was set by the reverse method, working with stones that were first sawed into tile-shaped pieces $\frac{1}{8}$-inch thick and $\frac{5}{16}$-inch square ($3 \times 8 \times 8$ mm.), then cut into final form with tile nippers. The girl's face is of Connemara serpentine, her hair of Persian and Chilean lapis with pieces of brownish aragonite in between.

chalcedony, colored agate and rose quartz yield a palette of fabulous tones. Gem stones might serve as the crowning touch of a large mosaic piece, but are most often used for smaller, intarsia (inlay) mosaics which require much painstaking work.

As an example of price, a kilogram (2.2 lbs.) of Chilean lapis (specific gravity 2.5) costs perhaps U.S. $10-$20 in raw form (about the size of a fist). Persian lapis costs several times as much. In general, gem stones are not cleavable with a hammer. The waste would be painfully high. They must be sawed with a lapidary diamond saw or ordered already cut into pieces.

Cast Stones

Another way to obtain blue stone or other colors that may not be available locally is to create it from ordinary Portland cement. Building supply firms carry color-cement mixes or at least cement and a ground color that you can combine yourself. You can add to the mix Jurasite (a stone from which a ground color is made) in order to produce stones with granular surfaces, but not in excess of the proportion of one part cement to three parts supplement.

Mix the color and cement with enough water to give the mixture a runny consistency. Pour it out freely onto a flat, oiled surface or into a small retaining frame. After two or three days, you can remove the frame but, like all cement products, this "do-it-yourself" material does not completely harden for several weeks so don't attempt to break it up too soon. It is also possible to cut the cement cake into small pieces when it starts to set after half an hour or so.

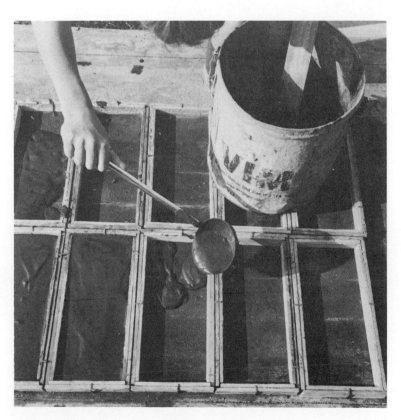

Use Portland cement mixed with ground color to produce "stones" of colors that you cannot find in nature.

A variation of this procedure is to pour a wet mortar mix of one part Portland cement and three parts fine sand into a three-eighths inch (1 cm.) high, oiled retaining frame. Tamp the mortar firmly with a mason's trowel or a spatula until the moisture rises to the surface. Then sprinkle the surface with a dry one-to-one mixture of Portland cement and powdered earth-color pigment (green earth, burnt sienna, burnt umber, etc.) and trowel it smooth. This results in a slab of ordinary cement with colored surfaces and, therefore, yields tiles that have only one usable face side. For brightening up the color or toning it down, as the case may be, add white or black cement to the mixture.

Organizing Your Finds

At first you should have little difficulty in keeping your work area in order. You will probably have just a few pounds or kilos of stones and some basic tools. The stock of stones has a way of growing, however, as pounds become hundredweights and hundredweights turn into tons without ever seeming to be too much. When you return home from gathering natural stones, don't just throw them into a pile nor erect a stone wall around your house or studio. Sort the stones by color: yellow, red, green, black, etc. Put the larger stones in small, flat boxes which can be left lying on the ground. Put smaller stones into tin cans and the really

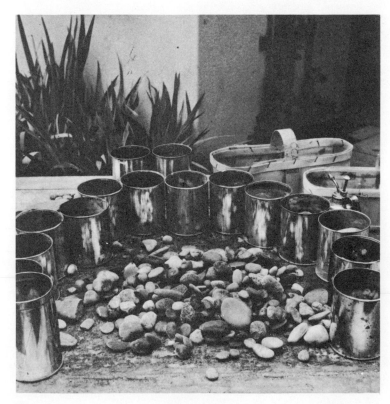

After a day of collecting, sort your finds by color.

As your stock grows, some sturdy shelves will be useful.

tiny pieces into match boxes. Put these pigeon-holed goodies into some kind of filing order with the most used colors close to your worktable or in the order of the color wheel, orange, red, violet, etc.

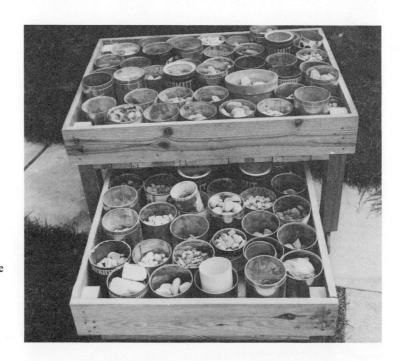

Nested tables take up little space, yet keep stones close at hand while you work.

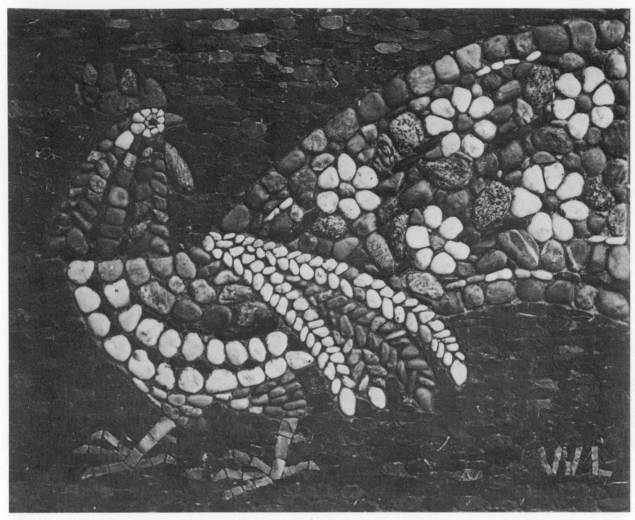

This fanciful bird with flowers among its tail feathers was created with a mixture of split and whole stones. Split stones can be used with either the flat or rounded side up. If you are working on a large size project, remember that using halved stones is a good way to keep the weight down since the supporting slab can then be thinner.

Tools

For the most part, ordinary household tools will be all you need for mosaic work, especially if you are good at improvisation. Some special tools, however, will lighten and speed your work.

Support Wedge

Some natural stones can be used as you find them for mosaics. Most, however, need to be split to reduce them to a more convenient size and also to reveal their often more attractive inner surfaces. An ideal support wedge for splitting stones is the hardy or anvil chisel that blacksmiths use for cutting off bolts, rods, etc. Its flat sides are ground to a wedge-shaped

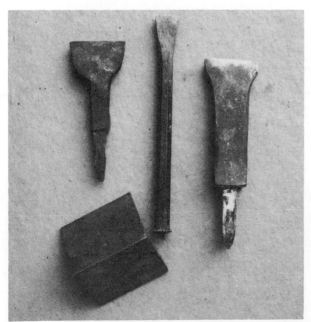 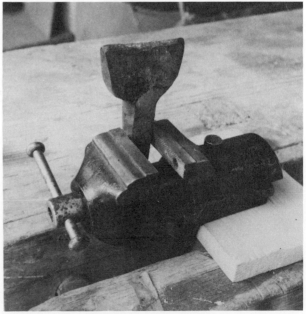

The main tools for splitting rocks are a steel wedge and a hammer. The wedge goes underneath the stone and a blacksmith's anvil chisel or hardy embedded in a length of log works best although a broad chisel or even a piece of angle iron make acceptable substitutes. A metal vice will serve in place of the log.

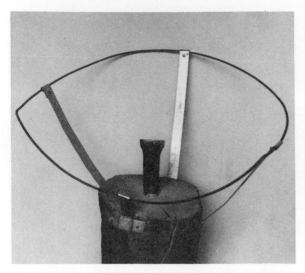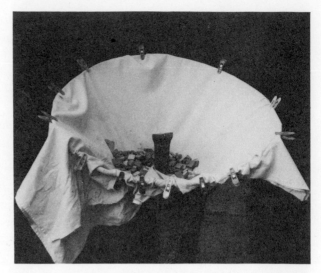

A useful catch-basket for stone chips can be made from some pieces of metal, some cloth and a few spring clothespins.

edge, like the inverted V-shape of a house roof. Mosaicists generally embed the shank end of the hardy into a knee-high log, which allows them to cut stones from a comfortable, sitting position. This is an important consideration since stone cutting will likely take up half of your working time! An ordinary cold chisel secured in a work bench vice will serve for splitting a few small stones but this arrangement tends to jump around quite a bit when you are hammering.

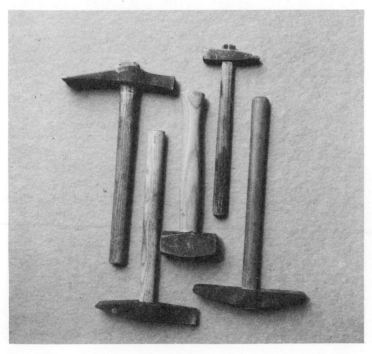

Hammers are available in a variety of weights and shapes.

You can make an extremely useful catch-basket for stone fragments using just some cloth, three pieces of strap-width sheet metal supporting a large wire lampshade ring and a few spring clothespins. This assembly will save you from having to pick up every other stone from the floor and prevent your having stone chips everywhere underfoot. If the metal ring bumps against your arms, simply bend it down a little in front. Cut a hole in the middle of the cloth to let the hardy pass through and then fasten the fabric to the ring with the clothespins.

Hammer

The best tool for splitting stones is a light mason's hammer with a head that is flat on one side and wedge-shaped on the other, weighing from 10 to 14 ounces (300 to 400 grams). A somewhat lighter hammer will do for light pebbles or gravel. For heavy slabs or quarry stone, you may need something as heavy as 2 pounds (approximately a kilogram). The hammer should be tempered so that the metal is hard enough to stand up to the stone.

Additional Tools

Besides the hardy and hammer you will also need a pair of long-handled nippers for cutting off corners and projecting points, a spatula or spoon for mixing mortar, a small trowel, two or three metal or plastic containers to mix mortar in, a pair of tongs or large tweezers for setting small stones, an awl for scraping mortar out of cracks, a small star-drill for making holes in stones, and a light, round-headed wooden mallet when using the indirect setting method. You will also find a round bristle brush, a sponge and some rags useful.

The tools you will need for making frames are a measuring rod or tape, a pencil, a carpenter's square, a saw, a wood rasp and some sandpaper.

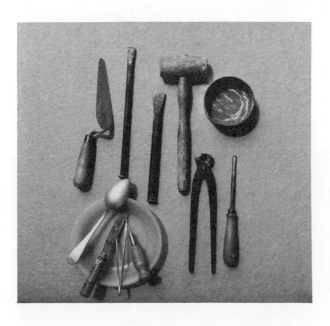

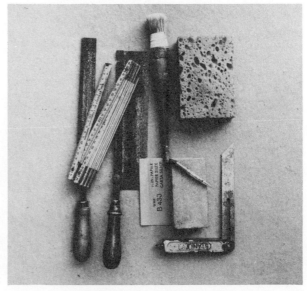

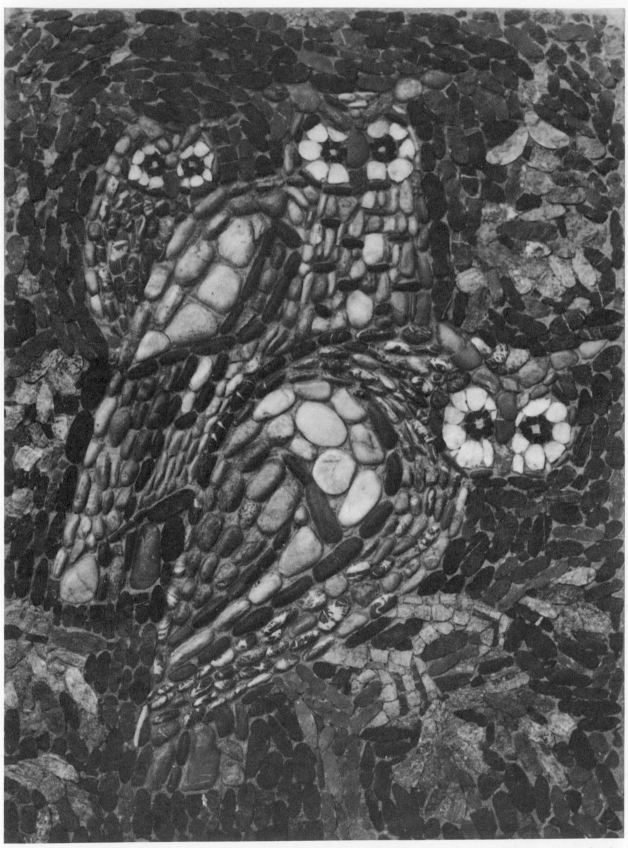

The mortar between the stones is prominent in this large mosaic. You can choose a contrasting or neutral-color mortar depending upon the effect you wish to create.

16

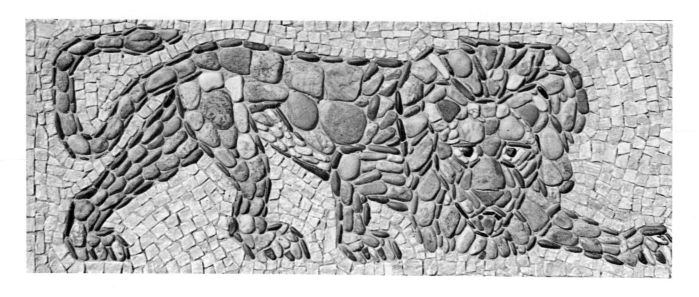

(Above) The body of this stalking lion is made up entirely of smooth pebbles gathered from a stream bed, set against a background of squared pieces of blue marble. The yellowish brown of the lion makes the background seem bluer and just the opposite in tone. (Below) This free-flowing mosaic of triplets is done in classical style. The faces are of flesh-toned limestone, the hair consists of split river pebbles. The background color was created by adding terre verte directly to the mortar.

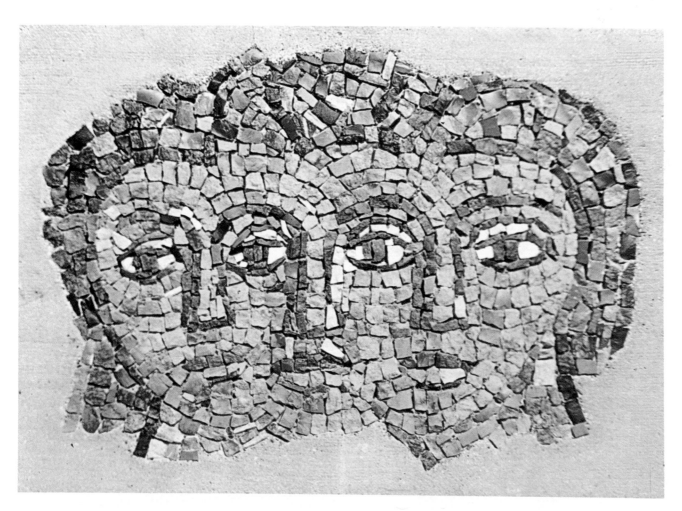

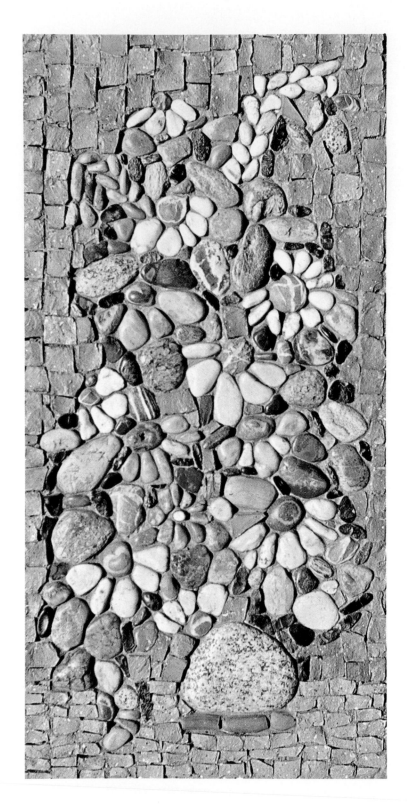

This flower mosaic was created by the direct-setting method. Stones collected from stream beds make up the flowers, the vase itself is an attractive piece of granite. The background consists of stones made from colored-cement.

Stone Splitting

On this topic, no amount of instruction can take the place of experience. Here are some hints to get you started but remember that every blow of the hammer upon intractable stone will teach you more than a page of directions.

What does successful stone splitting depend upon? The two opposing forces—the underlying support and the blow of the hammer from above—

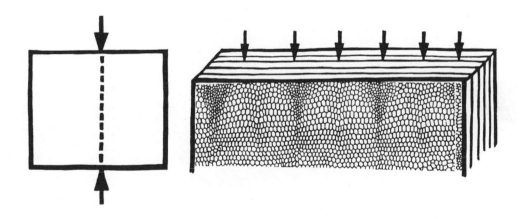

cause the grain of the stone lying between them to give way and to crack or split. You must always wear a pair of goggles or safety glasses when breaking stone to protect your eyes from flying chips.

For smaller pebbles and pieces of marble, a single blow is usually enough. Holding the pebble between your thumb and forefinger, rest it on the anvil hardy or chisel along the line where you wish the break to occur. Tap the pebble lightly for taking aim at the break line and then whack it sharply without shutting your eyes. Split the rock into slices and then square off each slice into rectangles. Each rectangle can then be halved, quartered, cut into eighths or to the smallest size needed, down to that of a pinhead.

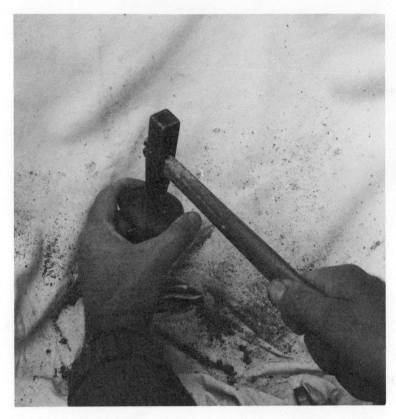

Successful stone splitting depends upon the opposing forces of the wedge support below, the blows of a hammer from above.

Large pebbles and well-shaped pieces of marble often have a will of their own. The grain must first be loosened up along the full length of the desired break with a series of moderate hammer blows (be sure to shift the stone back and forth on the underlying wedge as well) until the split occurs.

Thick slabs and slab-shaped quarry stone can be broken up into irregular pieces with a single blow of a heavy hammer although this usually results in a great deal of waste. It is better to use the time-tested mason's method. With a hammer and chisel, pound a groove across the face of the slab and, on the backside, chisel another groove directly opposite the first. Lay a piece of wood under one or both edges and

Slabs of stone need to have a groove chiseled along the break line before working them with your hammer and wedge.

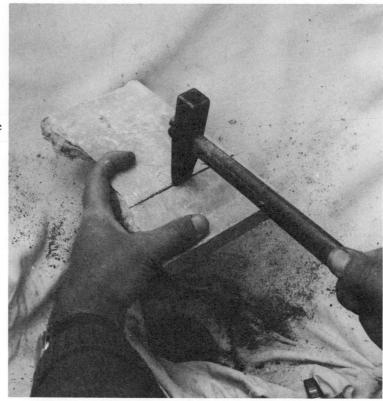

deliver a few hammer blows along the groove until the slab splits as desired.

Slate, quartzite, shale and other stratified stones split easily in the direction of the stratification. Even large slabs can be split along a seam with a few blows of the cross-peen (wedge side) of a mason's hammer.

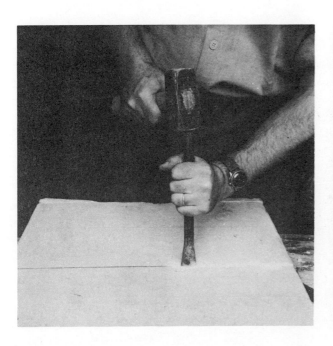

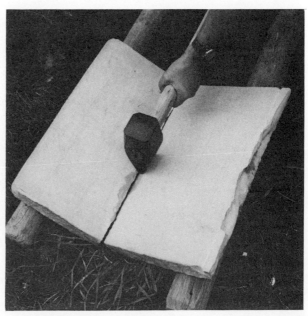

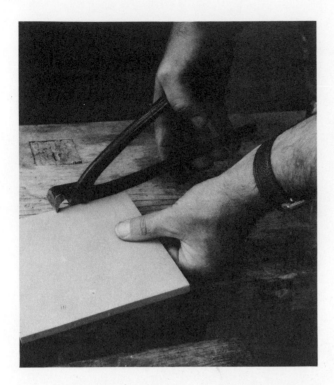

Use tile nippers to shape small pieces of stone or to trim off rough edges.

For trimming irregular edges or for cutting out the smallest squares, use a pair of nippers of the type used for ceramic tile. When cutting small squares in two, hold your free hand over the jaws of the nippers so that the two resulting pieces of stone don't fly off. If the piece is large enough, hold it at one edge and set the nippers about one-eighth inch (2 to 3 mm.) in on the opposite side. The break usually succeeds and you find yourself with both pieces in your hand instead of having to run and fetch them back from the corner of the room.

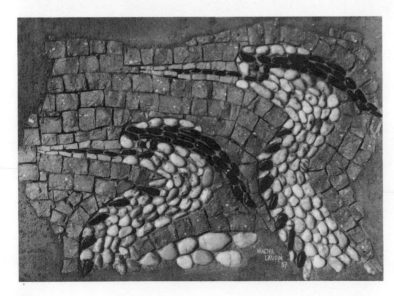

Leaving exposed mortar as part of the surface of a mosaic creates an interesting effect.

Samplers

Just as a seamstress may try out a variety of stitches on a sampler, a mosaicist may try various arrangements of stones to create different effects. The following illustrations suggest the wide variety of texture and appearance that you can create just by the manner in which you place the stones. Creating some actual sample slabs of your own may suggest additional possibilities but will assuredly give you a feeling for structure and teach you to consider the shape of each single stone to find its proper place in the overall design.

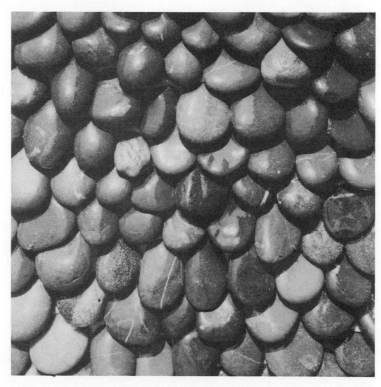

Setting stones at an angle and somewhat overlapping one another produces a naturalistic representation of feathers or fish scales.

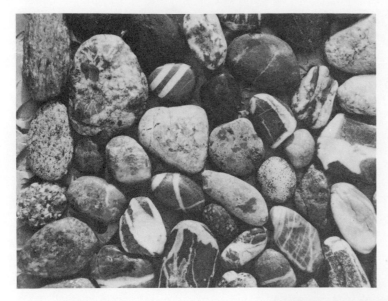

Colorful pebbles laid out flat serve for fast coverage of large surfaces like pond bottoms or walls.

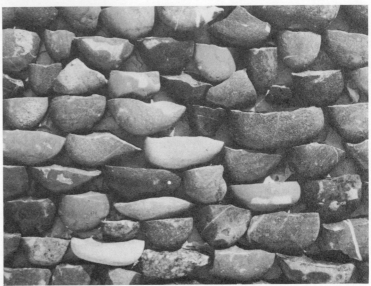

Pebbles cut across the middle, then laid flat, are good for decorative construction such as borders.

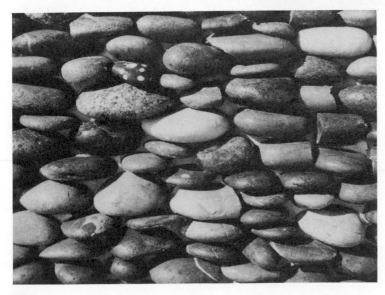

Pebbles cut across the middle, then set with their rounded sides up save on material.

Pebbles cut in half with their broken face up create a lively background due to the natural tone variations.

Squared pebbles with their natural surface up produce a combination of natural beauty with traditional technique.

Pebble slices give emphasis to the lengthwise direction of the pieces, especially useful for outlines.

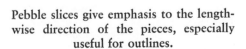

Cube-shaped stones are best laid in parallel rows. Five sides may be irregular but the surface face should be flat.

Free-form stones are easier to cut than regular shapes but are slower to set since you always seem to be searching for a chip to fit a particular space.

A fishbone design of cut and uncut stones serves for decorative lines and ornaments, sometimes for certain animal representations.

Planning a Mosaic

Use a regular drawing charcoal to work up a design. Since this material wipes off as easily as it is put down, you can alter and improve your sketch as many times as necessary. Thanks to the beauty of the stone itself, something good often comes from even an indifferent design. In working with natural stone, the artist's feeling for his materials and for the possibilities they afford is more important than his skill at drawing or painting. Though drawing does indeed enter into the mosaic process, traditional methods of working—the art of line and the joy of detail—must be subordinated to the coarser medium.

Two maxims apply from beginning to end: "Large is simple" and "Sketching means to leave out." Both say the same thing, namely, that in creating a design for a stone mosaic, you must seek out or abstract the major elements—the silhouette of an animal, the front view of a head, the non-overlapping parts of a grouping of objects—and simplify them, leaving out details if necessary. The fixed disposition of foreground and background is also essential to any plan.

It is futile to attempt to figure out beforehand the exact size, arrangement or color tones of the individual stones. The first stone to be set in place is already striding along in its own, self-willed way. The second stone will be affected by the first, the third by the second and so on, the project proceeding on an elastic basis with the work sometimes travelling in unexpected directions. In effect, this is quite pleasant, for the mosaicist does not merely make a copy of the preliminary work, the original design.

A small mosaic may be set spontaneously without a preliminary design. This does allow for free invention, daring improvisation and sometimes beautiful inspiration, but ordinarily you will want to set from a sketch or cartoon.

Setting from a Sketch

For smaller mosaics, you should be able to use a small sketch placed off to the side as a guide. Sometimes the design can be followed exactly,

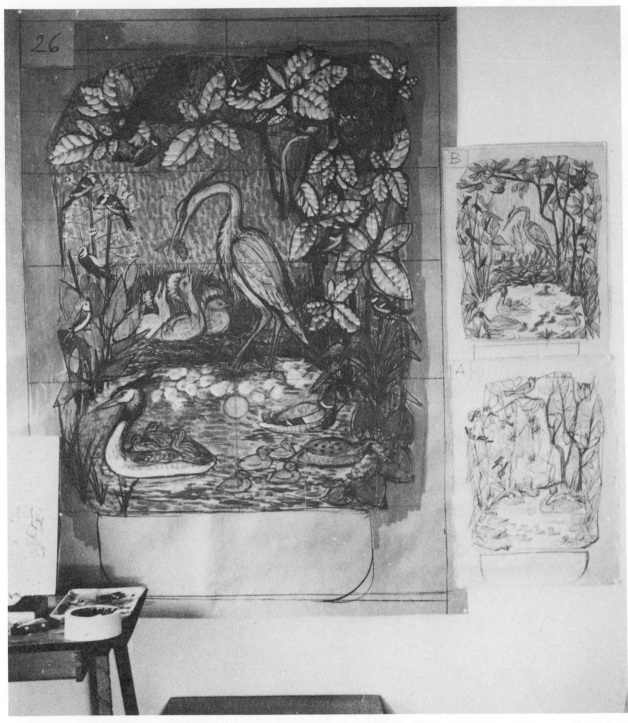

A complex mosaic calls for a full-size cartoon, enlarged from working drawings. This is especially true if the final mosaic must fit into a particular space. The finished mosaic made from this cartoon is shown on page 72.

other times the work must proceed more freely. The outlines cannot be taken too literally; pursuit of the design must remain flexible. For larger mosaics you may want to do a freehand transfer by making scratches in the setting medium with an awl or something similar.

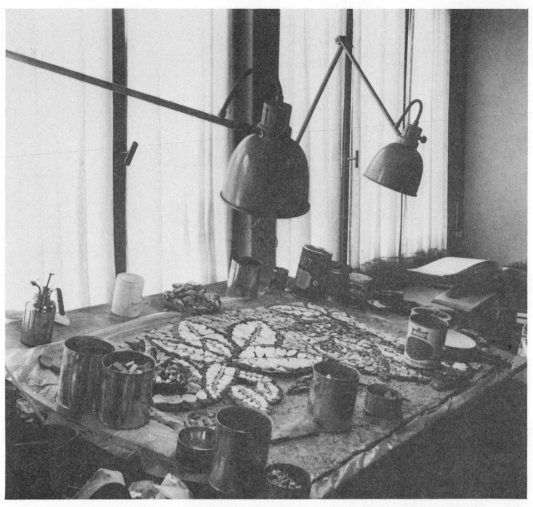

As a base for setting a mosaic, a slanted top table is better than a flat one because your view of the surface is less foreshortened and it is easier to reach the top edge of the work. A tilt-top artist's drawing table works well, of course, but you can create your own simply by sliding a piece of lumber under the far side of your setting board.

Setting from a Cartoon

This is the wall painting or fresco technique using a completely detailed, full-size original drawing (the cartoon) as a bridge between the sketch and the finished work. The outline must be transferred from the cartoon to the setting medium. To do this, draw or trace the design onto a piece of tissue or tracing paper. Then lay the tracing on a piece of cardboard, insulation board or on a layer of newspapers. Go over the lines of the tracing with a pattern-perforating wheel such as used by seamstresses and available at notion supply stores. If you have no wheel, you can use an awl or pointed punch with a carpet hammer to make the necessary series of holes along the lines of your cartoon.

If you are working with the direct setting method where stones are placed right into the wet mortar, you can only transfer a section of the pattern at a time. In this case, lay the tracing on the setting mortar and tamp the perforations with a small bag of colored chalk, forcing the chalk through the perforations.

With the indirect setting method where the stones are first set into Plasticine or clay, perforate the tracing directly on the temporary setting medium itself. If you don't have a perforating wheel available, simply lay the tracing directly on the Plasticine and press the outlines through with a fingernail or round-pointed instrument. Complete the transfer freehand by

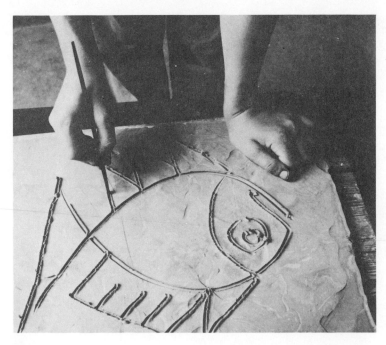

For indirect setting, scratch the outline of your design into the surface of the temporary setting medium.

scratching the design into the Plasticine. If you happen to make a mistake, you can correct it by smoothing out the surface with a fingertip or the ball of your thumb.

Materials for Direct Setting

The materials required for making natural stone mosaics vary somewhat depending upon whether you are setting with the direct or indirect methods that are described in detail in the chapters that follow. In a few words, direct setting is simply a matter of spreading mortar on the surface destined to receive the mosaic (a wall or framed board) and bedding the stones in it.

Before you start working on a project, consider what materials you will need and do a quick calculation of quantities. Once you have the basic tools, your expenses will be mainly just the cost of cement and sand. These are quite inexpensive and if you use natural stone that you have gathered yourself, the cost of producing a mosaic will not be a burden at all.

The Base

Any setting base must be rough and porous so that the direct-setting mortar will adhere well. An ideal base is asbestos-cement wallboard, a well known building material available at lumber yards and building supply firms in 4 ft. × 8 ft. sheets of various thicknesses—$\frac{1}{8}$-, $\frac{3}{16}$-, $\frac{1}{4}$-, $\frac{3}{8}$- and $\frac{1}{2}$-inch. The $\frac{1}{4}$-inch sheet will do for a small mosaic, but the larger the area to be covered, the thicker the sheet should be. Asbestos-cement

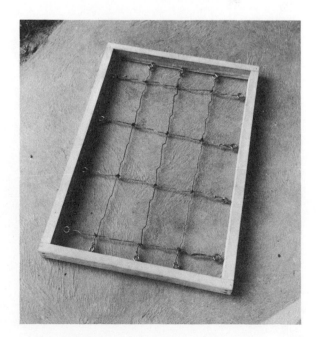

To make your own concrete base for direct setting, first construct a wooden frame of the proper size. Put in some screw eyes and run pieces of heavy wire between them to reinforce the concrete.

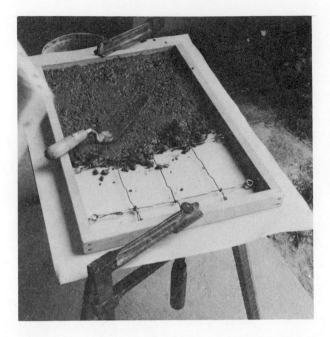

Use an oiled board as a support (oil prevents the concrete from sticking) and fasten the frame to it with nails or clamps. Fill the frame up to ⅜ inch (1 cm.) from the top with a mixture made of 1 part cement, 3 parts coarse sand, and a little water. Tamp it down but do not trowel it smooth.

board is rock hard, but you can cut it with an ordinary hand saw or an electric circular saw. You can also divide it along a straight line by scoring the sheet deeply on one side and bending it over an edge. If you are dividing a large sheet, you will have to slide a piece of lumber underneath to serve as the breaking edge.

A number of insulation boards made of wood or paper fibre and cement are also on the market. Mortar adheres to them quite well but they are not as sturdy nor as rigid as wallboard. Thin sheets of plywood tend to warp easily, resulting in a ruined or, at best, an uneven mosaic.

If the mosaic is to be hung on a wall, any of these bases will need supporting frames of wood or, if they are very large, of angle iron.

For a small project, you can use a sheet metal form to make a base. If you oil the form before pouring the cement, the finished base will release easily when you turn the form upside down.

Sheet metal can serve as the base for small mosaics. Use a pair of pliers to bend up a ¾ inch (2 cm.) border around all four edges. You can also use a baking pan or similar utensil if the dimensions are right. For a frameless mosaic, oil the pan beforehand and the finished work will release easily when you turn the form upside down. If you wish to retain a metal frame around the mosaic, you will have to make the border slightly higher so as to be able to bend it down later over the finished slab, anchoring it within the frame.

Frames

A mosaic should properly be considered an integral part of the architecture—an element fitted in among flagstones or into a wall—actually a piece of the very floor or wall itself. Nowadays, of course, when many of us are tenants and more inclined to change our residences, a movable mosaic on a frame that can be hung with hooks and eyes is more in order. A support frame for a mosaic is not the same as the decorative frame you might put around an oil painting. A simple support chassis will do, since the surrounding wall surface enhances the mosaic and, in accordance with the laws of contrast, accentuates the beauty of the composition. Every mosaic requires a wooden frame while it is being worked up, but it need be nothing more than some wooden planking to contain the mortar and to assure clean edges. When the work is completed, the rough frame will serve to transport the mosaic to where it will be displayed and if you want, it can remain in place and hang on a wall, prettied up with a little white paint. You can remove the frame if installation directly into the wall itself is possible. A mosaic generally does not need a gilded frame or one of precious wood; you can settle readily upon some strips of planed fir or pine.

For small mosaics on asbestos-cement wallboard, use wooden strips ½ inch square (about 1 × 1 cm.) to make the frame (American lumber yards supply this as ½″ baluster molding). For larger works, use standard 1″ × 2″ lumber (or 1.5 × 3 cm.). In any event, the wooden frame should extend about ½ inch (or 1 cm.) above the surface of the support sheet, assuming that you are working with stones that are less than that thickness. With thicker stones, you must increase the height of the frame accordingly. Note, however, that while thick stones and heavy layers of mortar greatly increase the weight of the mosaic, they add very little by way of strength. Mosaics that cover an area of less than a square yard (a little less than a square metre) do not need to exceed a total thickness of 1¼ inches (about 3 cm.). For mosaics of 6 square yards (5 square metres), you should use a frame of angle iron and the thickness of the finished stone slab together with the base will be about 2 inches (5 cm.).

For assembly of the frame, using nails is the quickest way to fasten corner joints, but the results are the least solid. Dull the points of the nails with light hammer blows to minimize the risk of splitting the wood. Use a nail set to sink the nail heads an eighth of an inch (2 to 3 mm.) below the

surface of the wood. You can close up the holes by dropping hot water on them or fill them with putty, plastic wood or plaster.

Fastening with screws assures a firmer corner. Use flathead wood screws of a size appropriate to the thickness of the wood. Pre-drill the holes and enlarge the surface opening with a 60-degree countersink to drop the heads below the surface.

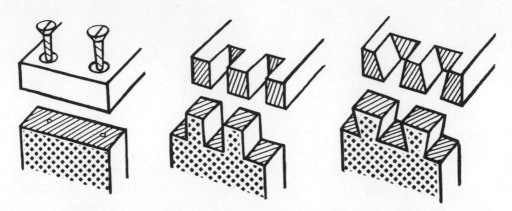

The corners of a frame can be fastened with screws, box joints or dovetail joints.

The strongest and most craftsmanlike way of fastening corners is to use box or dovetail joints if you have the tools and know-how to do it. Fasten the joints with waterproof glue.

To finish the frame, plane off any rough spots or excess wood and bevel the outer edges. Smooth with a rasp and polish with some sandpaper before brushing on a coat of flat white paint.

Hangers

To provide a means of attaching the finished mosaic to a wall, twist four heavy screw eyes into the backside of the frame, one near each corner. Draw some heavy wire or double-woven picture frame wire through the two eyes nearest the top. The two lower screw eyes serve to hold the bottom of the mosaic the same distance out from the wall as the top so that the front surface is perfectly vertical. Hang the wire over screw hooks fastened into the wall at the appropriate height. Plaster walls require special heavy-duty picture hooks. If you have brick, concrete or other masonry walls, you will have to drill holes with a star-drill and hammer or with a carbide-tipped masonry bit in an electric drill. Install wood dowels or lead expansion plugs into the holes and secure the hooks into these.

You can build in a hanger by fastening a length of wire to the inside of the support frame before pouring in the mortar. You can add this later as well by boring two holes in the backside of the hardened slab, then glueing in the ends of a heavy curved wire with epoxy cement.

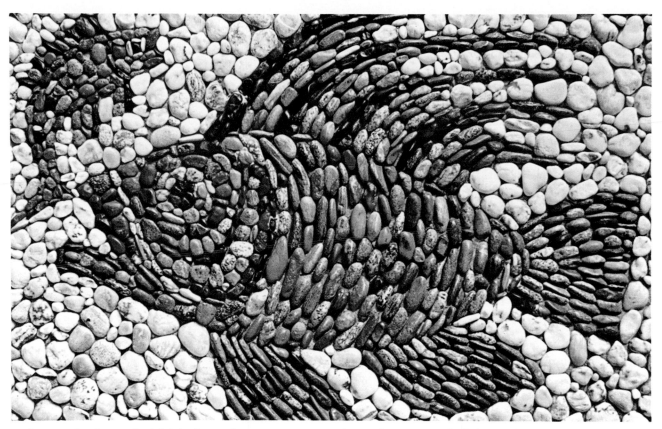

This mosaic of two playful fish shows that uncut stones can be used just as you find them. This work was set by the indirect method with a layer of sand used to keep the joint mortar from coming up to the surface of the stones. No traces of cement are visible in the white background—the most beautiful joint!

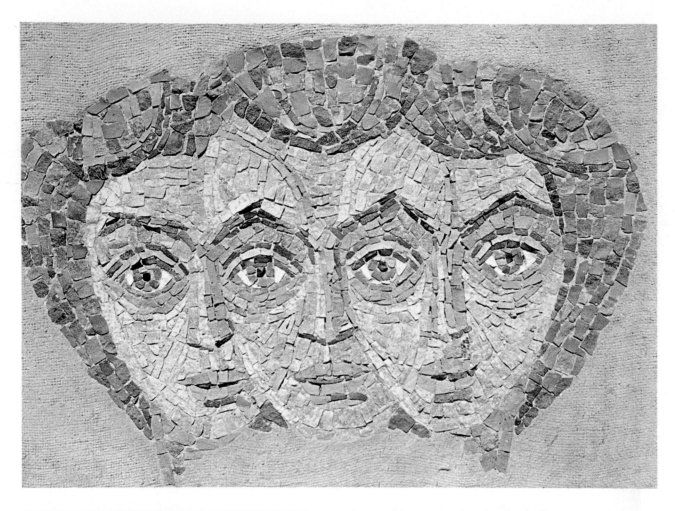

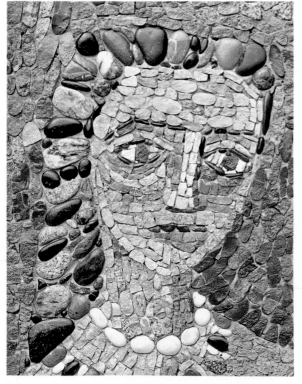

(Above) This mosaic of triplets is a refinement of the theme shown in classical style on color page A. Here the faces are of greenish marble with shading of lilac color-cement stones. The hair is formed of cut pebbles. The charming texture of the background is the result of pouring the concrete backing onto a layer of burlap.

(Left) Here is an interesting combination of cut and uncut stones in a mosaic of the head of a young girl. If pebbles made up the hair alone, they would seem out of place, but by repetition in the necklace, the pebbles enter into the design and present an interesting contrast of material. The contrast is further heightened by using green stones for the face set against a red stone background.

D

Binding Material—Mortar

Much technical literature exists on this topic, but the following information should be sufficient for almost any mosaic project.

Cement

This is a baked mixture of powdered limestone, clay and gypsum which serves as a solidifying agent for sand and gravel. It is quick-setting, hardening in 2 to 4 days, depending upon the season. Slow drying reinforces the solidity and minimizes the formation of hairline cracks. In summer especially, keep the poured layer damp by covering it with wet cloths or burlap bags laid over the surface or by occasionally spraying. Cement becomes really solid only after several weeks.

White Lime

For making light-colored mortar, it serves as a softener and retards drying when mixed with cement.

Black Lime

This is a brownish powder with a darkening effect on the mortar. It is obtained by burning limestone and then slaking the product. Mixed with cement, it has the same properties as white lime.

Hydrated Lime

Watered white lime, this is the classical binding material although it is hardly available any longer. To make it yourself, put some white lime in a large glass or glazed vessel and add water. Cover the container to prevent evaporation and add water from time to time. Let the lime soak for several weeks until you have a pasty fluid that is free of lumps.

Dispersion Paste

This is a white, synthetic resin paste used as a binder for exterior paint. It thins mortar to a milky consistency when added in a 1-to-1 proportion as mixing water. The setting time for the paste without cement is around 14 days, half that time if cement is added. It produces an extremely tenacious, sticky, crack-free and flexible mortar.

Some newly developed, synthetic binders work the same as dispersion paste but with a setting time of only 2 or 3 days. These are also mixed with mortar in a 1-to-1 proportion. The so-called adhesive mortars obtained with this material are excellent for patching and thin overcoatings or for binding layers.

Tile Cement

A slab-laying cement made of Portland cement and casein, it possesses the combined properties of cement (hardness, quick setting) and of the casein (adhesiveness). Do not mix it with sand! This will cause it to crumble into powder as it ages.

Mortar Formulas for Direct Setting

For all quick-setting mortars, use fine-sieved sand! Chips and coarse sand impede bedding in of the mosaic stones. Mix the dry materials together thoroughly first and then add water gradually.

Regular Cement Mortar (Grey)

Combine 1 part cement with 3 parts sand and slowly add enough water to give it the right, doughy consistency. This is the easiest mortar to make and use, but it turns very hard when it dries and, if corrections are to be made later on, they have to be done with the aid of a chisel. This mortar is widely available in ready-mixed bags.

Cement-White Lime Mortar (Light Grey)

This is composed of 2 parts Portland cement, 1 part white lime and 6 parts sand. First combine the cement, lime and sand, then, stirring constantly, add water little by little. The consistency is right when the mortar is uniformly wet but not runny.

To produce an "eternal" mortar that does not deteriorate and can be kept for months on end in a damp cellar if covered with wet cloth or burlap, mix 1 part white lime with 2 parts of cement but no sand. When you are ready to use it, mix in a little additional cement. Pure lime mortar becomes crumbly in a short time.

Cement-Black Lime Mortar (Brownish Grey)

The proportions for this mortar are 1 part Portland cement, 1 part black lime and 4 parts sand. Water is added as above to produce a brownish-grey mortar that is not so conspicuous between the stones.

White Mortar

Combine 2 parts white lime with 1 part white-colored cement and 4 parts of whitish sand.

Dispersion Mortar without Cement (Clear sand color)

Mix 1 part dispersion paste with an equal amount of water, then add enough sand to reach the consistency of a stiff dough. Remember, however, that this material requires a 14-day setting period. It sticks like glue to porous stone.

Glue Mortar (Light Grey)

Use glue emulsion thinned 1-to-1 with water as the mixing liquid added to a mixture of 1 part cement and 3 parts sand.

Colored Mortar

Any mortar can be colored by adding pigment dissolved in water or by using colored-cement in the mixture. Use only earth colors, such as terre

verte (earth green), raw or burnt sienna, raw or burnt umber, English or Indian red, vine black, etc. Chemical pigments are decomposed by cement. The color pigment or colored-cement is best mixed with water and added as a liquid to the finished mortar. An important point to remember in adding pigment is that the color will appear 50 per cent brighter when dry.

Materials for Indirect Setting

Summed up briefly, with this technique the mosaic stones are pressed into a temporary setting medium until the design is worked out, the stones are then glued over with cloth, removed from the temporary medium and the final mortar is poured in from the back.

Composing Board

This should be neither a good table nor a fixed workbench but the side of a packing crate, a piece of plywood, or even an old door—anything that is large enough and sturdy enough to serve as an underlay or support for the work, then for turning over the slab.

Setting Medium

There are two solutions for this—one that is very economical but slower and more difficult, the other a little more costly but quick and easy.

The inexpensive solution is clay rolled out to ¾ inch (2 cm.) thick. To keep the mosaic stones from sticking, dust the layer of clay with powdery sand or pumice powder. The disadvantage of clay is that it tends to harden during an extended work period, especially in warm weather. Spraying it with water will only wash away the sand or powder, allowing the stones to stick even tighter. During pauses in your work, you can cover it with wet cloths and wrap it in a sheet of plastic to retard drying. It is also possible to use wet, firmly-pounded sand as a setting medium although it is rather delicate.

The most practical if more costly solution is to use Plasticine (from an art supply store), a clay that has been moistened with mineral oil (the same as children's colored modeling clay). Choose neutral grey, however, or the color of the clay will compete with the color of the stones. Plasticine can be used over and over again for years if it is not left lying uncovered in a heated room. For a mosaic of 12 × 16 inches (30 × 40 cm.), you will need a little more than 2 pounds (1 kg.) of Plasticine.

Mortar and Concrete Formulas for Indirect Setting

Two different mixtures are used with the indirect setting method. The first is the joint mortar or grout that fills in the spaces between the stones. This is a mix of cement, lime and fine sand. It must be fluid enough (like syrup) so that, with a little shaking, it will quickly work its way into the finest cracks. It also needs a degree of elasticity so that no stones will fall

out even when vigorously shaken, yet corrections can be made and stones replaced if necessary. Here is the formula:

Joint Mortar

Combine 2 parts cement with 1 part white or black lime and 6 parts fine sand. Mix with water to a dough-like consistency, then thin down further to the fluidity of syrup. For a mosaic 12 × 16 inches (30 × 40 cm.), you will need about 1½ quarts (1¼ litres) of mortar.

Concrete

The second mixture is actual concrete, the same material used for paving. It provides support in place of the underlay board described for direct setting. The ingredients for concrete are: fine gravel, sand, cement and water. The coarse components of the amalgam strengthen the cohesion and the fine particles fill the spaces between the larger ones.

For a small or medium home mosaic, you don't need to use material that would serve for the construction of a skyscraper, but it does need to be more robust than fine sand. Choose fine gravel chips, an ideal material because of their irregular shape, or bricklayers' sand which usually also contains some fine gravel. You can use fine sand if you have to, but the finer the sand, the less its resistance to breakage. Here is the formula for concrete:

Use 1 part cement to 3 parts crushed gravel or bricklayers' sand. Add just enough water to dampen the mixture. The wetter the concrete, the less solidly it sets. To make a ¾ inch (2 cm.) base for a 12 × 16 inch (30 × 40 cm.) mosaic, you will need about 3 quarts (2½ litres) of mortar.

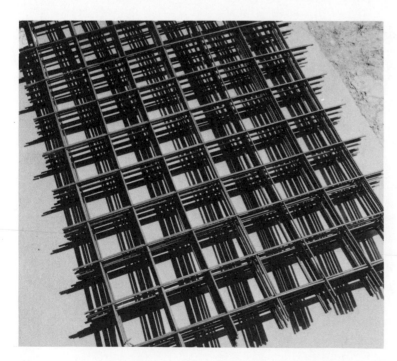

Steel mesh grating is the best reinforcement for large slabs of concrete.

A glue pot and dry (bead) glue is essential for one of the steps in the indirect setting method.

Reinforcement

The base layer of mortar or concrete needs to be strengthened with iron rods or a network of heavy wire. For small mosaics, however, no reinforcement at all is better than a bad one. For example, rods $\frac{3}{8}$ inch (1 cm.) in diameter are too large for a mosaic that is only $1\frac{1}{8}$ inch (3 cm.) thick and weaken rather than strengthen it. Similarly, too thin a grating, chicken wire and the like, which flexes with slight pressure on the cement, is the enemy of cohesion. Mosaic reinforcement has the same function as wall-and-girder reinforcement. It holds the assemblage together after the appearance of small cracks due to natural shrinkage and it holds the broken pieces of a dropped or fallen mosaic firmly in the slab.

The best reinforcement grids are made of steel wire about $\frac{1}{8}$ to $\frac{5}{32}$ inch (3 to 4 mm.) thick, with a mesh size of 4 inches (10 cm.). They are available from building supply firms and you can cut them to size with a hammer and chisel. A suitable substitute is to lay iron rods of the same thickness crosswise of each other. Bind each crossing together with wire, twisted tight with pliers.

Other Useful Items

A piece of plastic sheeting or oil cloth used as an underlay for the Plasticine will protect the composing board against the penetration of dampness. You will need a piece of porous burlap (potato sacking, canvas, etc.) to glue down over the mosaic stones once the composition is complete. To attach the burlap you can use dry cabinet makers' glue. To prepare it, put the dry glue in a tin can and barely cover it with cold water, then set the can into a shallower pot of hot water (like a double boiler). When every granule is dissolved, the glue is ready for use and

should have a consistency like oil. If the glue gets too thick (from evaporation), add hot water. Temperatures above 160° F. (70° C.) cause a brownish discoloration and reduce the strength of the glue. If your mosaic has a smooth, flat surface, a less tenacious holding power is required and you can use paste in place of dry glue.

Calculating Quantities and Weights

The volume of a mosaic is calculated by multiplying the length × width × thickness. If you measure in centimeters, you can convert your answer into litres simply by dividing by 1,000 (1 litre = 1,000 cm.3). To obtain the weight in kilograms of mortar necessary to fill the space, multiply the number of litres by 2.2, the specific gravity of water-mixed mortar or concrete.

If you measure in inches, your answer will be in cubic inches and you must divide by 12.5 to find the approximate number of pounds of mortar necessary to fill the space.

Examples:

Surface	30 × 40 cm. = 1,200 cm.2
Depth of mortar	2 cm. = 2,400 cm.3 = 2.4 litres × 2.2 = 5.28 kg.
Surface	12 × 16 inches = 192 sq. inches
Depth of mortar	$\frac{3}{4}$ inch = 144 cu. inches ÷ 12.5 = 11.52 lbs.

Direct Setting

This is the most commonly used method for creating mosaics. The stones are placed right side up and the design is developed as stone by stone is placed in its permanent position. With thin manufactured tiles, the pieces are first glued to a base and the grout filled in from the top. Working with natural stones, however, each piece is set directly into mortar that serves to fill the spaces between the stones as well as to fasten the stones to the setting base.

Whether you use asbestos-cement board, bricks, concrete wall or fibre board for the base of your mosaic, every material draws a certain amount of water out of the mortar. As the mortar becomes dry, it quickly loses its flexibility, turns crumbly and makes bedding in the stones difficult. Because of this moisture loss, mortar should be laid on over just a small area at a time and all of the stones for that area set before proceeding to lay more mortar. The size of the area to be covered each time depends upon how quickly the undersurface draws out the moisture, the size of the stones being used, how quickly you work, and the temperature and humidity of the surrounding air. Under the worst circumstances, the mortar may have to be restricted to an area the size of the palm of a hand.

While this series of small steps may sound tedious, it is really easy and amusing; it is the same method used by professional tile setters.

For small mosaics that can be completed in three hours or less, you can mortar over the entire surface if you use one of the following materials:

1. A setting base such as sheet metal that does not absorb moisture.
2. A thick layer of mortar 1¼ to 1½ inches (3 to 4 cm.) which will hold enough water to allow the ground to draw some water from it without drying up completely.
3. Mortar to which you have added a large quantity of dispersion paste.
4. Fish-glue mixed 1-to-1 with the mortar.

Certain disadvantages, however, offset to some extent the convenience of being able to spread mortar over a larger area. Sheet metal is a difficult material to work with; a thick layer of mortar results in heavy weight; dispersion paste discolors the surface; fish-glue dries so slowly that it takes weeks before the mosaic is ready and, moreover, it is not waterproof.

Direct setting begins like this, with a framed base to spread mortar on, one small area at a time.

Beginning a Project

Assemble your materials starting with the support. A framed sheet of asbestos-cement or similar base is easiest to work with. Smooth materials, such as polished marble, plate glass, plastic tiles, etc., can be used as a mosaic support provided the mortar is mixed with a synthetic cement additive. Your supply of stones will presumably have been gathered, split and arranged beforehand and a sketch or plan for the mosaic worked out. Gather your tools, some short lengths of board for levelling off the surface of the mortar, a bucket of water and a sponge or some rags. Mix your direct-setting mortar and you are ready to begin.

Setting

In placing stones, always begin with the main subject, then do the background. Start with the central part, such as an eye or a face, working the design around it. When you are ready for the background, set the rows surrounding the motif first, then the remaining surface to the edge of the field. The principle here, then, is to begin in the middle, progressively adding stones right up to the border. The surrounding background area is thus subordinate to the fundamental statement of the picture. The ideal is to be able to work up the whole composition simultaneously, the normal method for a painter to use, providing the opportunity to view each part in respect to everything else. Mosaic-making cannot proceed this way, however. It is simply a matter of setting stone after stone, adapting the later pieces to what has gone before.

Moisten the surface of the setting base well (a "must" for good adhesion) and lay a small, flat dab of mortar on the surface at the point where you intend to start. Keep the surface of the mortar at least ⅛ of an inch (2 to 3 mm.) below the top of the frame. Set the first stones into the mortar so that they project about 1/16 inch (1 to 2 mm.) above the height of the frame.

Begin setting with the most important feature of the design and work outward in ever-widening circles.

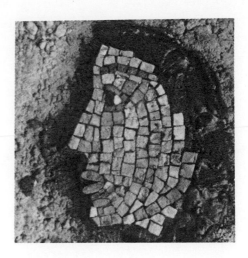

Thicker stones thus must be pressed deeper into the mortar while thinner ones may need to be raised up by placing a small dab of mortar underneath. Set each stone with its most attractive side upward and level with the others. Use tweezers for small stones, tongs for larger ones.

After a time, you will find that the mortar has its best minutes behind it. When it becomes crumbly and cracks as you press a stone into it, edge off the unlaid, surrounding mortar with the spatula, lightly sloping it downwards and away from the outermost stones. Blend fresh mortar from the mixing container into the slope. Add a few drops of water to the container of mortar from time to time to compensate for evaporation.

Five Common Mistakes to Avoid Are:

1. Mortar that is too thin. The stones sink gradually down into it.
2. Pressing stones in too deeply. The mortar will squeeze up between the stones and flow out over the surface.
3. Not pressing the stones deeply enough. They will not hold securely.
4. Waiting too long to level off a stone. The mortar takes hold very quickly and if the spaces between stones are narrow, you may find it difficult to lift up any stone that is too low.
5. Using sand that is too coarse in the preparation of your mortar. The mortar will not give way readily to accept the stones.

A question to be answered is how wide the spaces between the stones should be. You must decide whether you want the mortar or the stones to carry the effect of the picture. If you agree with most mosaicists that mortar is merely the means to an end and that the stones are the prime consideration, then, the answer must be: not a stone here and there, but stone close to stone. This does not mean they should be so jammed against each other that the mortar cannot squeeze into the joints. Ideally, the stones should be about $\frac{1}{16}$ inch (1 to 2 mm.) apart. It is not too serious,

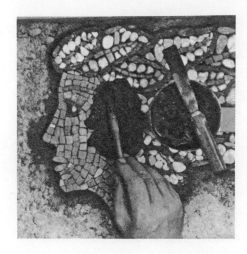

Fill the joints in from the top. Use a brush to spread mortar over rough surfaces, a spatula to spread it over smooth surfaces.

however, even if some stones have no space between them at all. The mortar should hold them firmly from behind, even so.

You can join a second area of mortar to the first within an hour, some on another day, or wait however long it takes for the arrival of new inspiration. Whenever you add mortar, it is important to moisten thoroughly the old mortar which you sloped off up to the outermost stones. Also wet down the place on the setting base where you plan to work next. Water alone will bring about good adhesion of the old with the new.

Levelling

One important step you must not put off is the final levelling off of the surface before the mortar loses its pliability. Use a piece of straight $1'' \times 2''$ board slightly longer than the length of the frame for this. Press it down on the stones until the board is resting on the frame. If the stones resist, hammer the board gently on top of the stones until they sink down to the level of the frame. As you press down on the stones, the mortar will rise in the spaces between them. If it overflows onto the surface of the stones, whisk it away with a small brush. If it does not rise up enough, brush a little fresh mortar into the joints. As the mortar sticks tightly to the porous stone, do not wait too long to do the final surface cleaning (with brush, sponge and/or rags).

Some mosaicists prefer not to level the work off completely. They see in a slightly irregular surface a certain charm which separates their mosaics

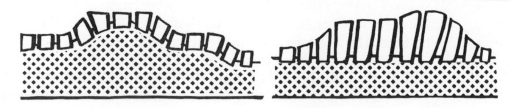

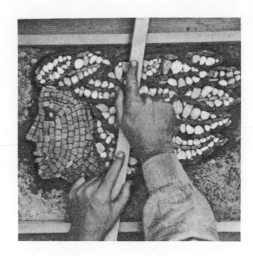

Level the stones as you go along to insure a smooth, even surface on the finished mosaic.

from commercially laid tile. Slight differences of level may be of artistic merit but pronounced differences of $\frac{3}{8}$ inch (1 cm.) or more seem to indicate a lack of skill or, at least, produce a kind of art that is not true mosaic. The technique, however, is simple enough when you are working with the direct setting method. You can control the level of the face surfaces of the individual stones either by spreading the mortar more thickly in certain areas or by using stones of varying thicknesses.

Consider the following: bright or light-toned spaces between the stones give the mosaic a net-like appearance and are disturbing to the viewer. To counter this, try using the colored-cement mortar discussed earlier. Joints that are too dark are less disturbing. The most beautiful effect is brought about by using a dark grey mortar and pressing the stones in just deep enough so that the cracks are two-thirds filled. Mortar that wells up too high in the joints can be washed out with a brush. The viewer then sees the shadows of the stones instead of the mortar itself and the mosaic appears covered with an even, unobtrusive network that has a subtle structured effect rather than a disturbing one. If, in spite of your choice of mortar, you feel that the color of the mortar in the dry mosaic is not suitable, you can still resort to careful patination (see next).

Patination

If you wish to subdue the color of the mortar showing between the stones or simulate an antique look, apply a small amount of vine black pigment or a dark cement color to a damp cloth and rub it into the spaces. Remove any excess with a clean rag.

Final Finishing

The final treatment of the surface cannot be done until the mosaic has hardened or you will risk having stones fall out. The purpose of finishing

is to restore the original color to the stones and to protect them from adverse atmospheric conditions. A simple and reliable way to do this is to wax the surface with hard floor or car wax. Be sure to use a non-yellowing wax (generally those containing carnauba wax). The waxing must be repeated two or three times because of the absorbent nature of the stones. Let the wax on the mosaic dry just as you would a waxed floor and then polish it with a soft rag or brush. The same treatment serves for year-round protection of mosaics mounted in outdoor walls. For walls exposed to rain, the treatment should be repeated every three months.

Direct Setting on Walls

This is obviously a more difficult task than working on a horizontal surface. Just applying the mortar is a problem since it tends to drop off easily onto the floor. Try to make it stay in place by pressing it down with a trowel, a soup spoon or a spatula. The professional procedure is first to plaster the wall with cement mortar followed by a $\frac{1}{2}$ inch ($1\frac{1}{2}$ cm.) layer of stiff joint mortar. Starting at the bottom and working up, press the stones deeply into the mortar so that it rises up almost evenly with the top surface of the stone. Before pressing the stones in place, thoroughly clean the edges that will be exposed as well as the surfaces. Italian specialists substitute a $\frac{3}{4}$ inch (2 cm.) coating of lime plaster in place of the cement base. To make the following layer of joint mortar adhere better, they make nose-shaped indentations close together in the lime with a small pointing trowel. A few over-careful mosaicists have been known to nail a wire netting over the plaster, but this is really unnecessary. If you feel additional security is called for, you can accomplish it without additional work by using a glue mortar.

Reverse Setting

Setting a mosaic on a vertical surface using the direct method is a difficult procedure even if you have had considerable experience. Either the stones slide out of position or the mortar pulls away from the base. One way to overcome these problems is to use the so-called reverse method of setting. With this technique, stones are first fastened face down to paper with the design reversed from left to right and vice versa, and then set in sections using the direct method and materials. All mosaicists should be familiar with reverse setting although it is really only suitable when the mosaic stones are of absolutely uniform thickness. The indirect method described on the following pages is far better and produces more satisfactory results when you are working with natural stones.

The first step in the reverse method is to create a full-size, mirror-image drawing of your design. Most people find it easiest to sketch out the design normally, flop the paper and trace the design through on the back. The reverse-image side of the paper serves temporarily as the setting base. Following the outline, place stones in position face down on the paper. Use water-soluble paste or glue to fasten the stones to the paper. This glue temporarily takes the place of mortar. Artificial glues (cellulose, glutoline) have the advantage of keeping for a long time without a preservative.

Without a doubt, working in reverse leads to a lot of head scratching. What can be done easily as a linoblock or a woodcut soon gets out of control in mosaic-making since, as the work progresses, the stones constantly seem to outrun the pre-drawn sketch. An even greater disadvantage, though, is that with the stones being set upside-down, that is, with the picture side out of sight, the artist has little feel for the development of the work. When the face of the mosaic is finally revealed, the work may be full of surprises, since the picture sides of the stones often do not correspond to their work sides. Although accidental effects can be attractive, they can also be disastrous and do not really belong in a consciously-developed creation.

One possible, although inconvenient, solution to these problems is to use a piece of plate glass instead of paper for the setting base. Lay the

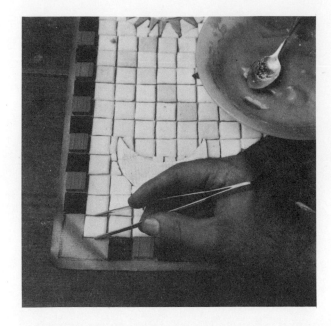

In direct setting, the mosaic pieces are pasted face down on a full-size pattern. This method requires that all the pieces be of uniform thickness, so it is most often used with manufactured tiles.

glass over your sketch and trace the design onto it with a grease crayon (china marker). Then simply turn the glass over to produce the mirror image of the sketch. You can check the progress of the stone placement by getting underneath the glass or lifting it every now and again for a look.

Another alternative if the stones are of equal thickness is to paste them picture-side up directly onto the cartoon. This eliminates the reverse tracing of the design and the upside-down setting. When the design is completed, lay a piece of paste-covered paper over the entire mosaic and allow it to dry; it will adhere to the face of the stones. Turn the whole thing over when dry and remove the cartoon from the back of the stones by dampening it with a sponge and then peeling it away. You now have a ready-to-transplant mosaic.

Once the stone pieces are firmly attached face down to the paper, transfer the mosaic to its permanent support. Spread the base with a $\frac{3}{4}$ inch (2 cm.) thick layer of lime-cement mortar. Smooth and level the surface with a 1″ × 2″ board and a wooden cement float. For brick walls, plaster them first with granular cement mortar followed by regular plaster to a thickness of about $\frac{5}{8}$ inch (1$\frac{1}{2}$ cm.). Finish off with a $\frac{3}{8}$ inch (1 cm.) layer of fine sand joint mortar.

When the mortar is spread, lay the mosaic on top of it with the back of the stones (the work side) touching the mortar, the paper on top. Through the paper, press the stones into the mortar, using your thumb or the palm of your hand. The mortar must be of the right consistency—soft, supple and slow-drying.

With larger mosaics, the procedure is the same except that as large, heavy stones have a tendency to tear the paper, these bigger mosaics must be mounted in sections. Draw lines on the paper side of the mosaic, following

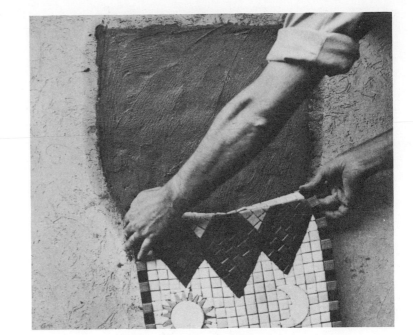

Attached to its paper
backing, the mosaic is
transferred to its
permanent location.

the spaces between stones, dividing the mosaic into manageable sections.
Mark each section with a letter or number. The smallest elements can be
about the size of your hand. Cut along the lines with a knife. Spread mortar
to receive the first section, bed in the stones and slope off the mortar all
around the element. Cover a second area with mortar and repeat the

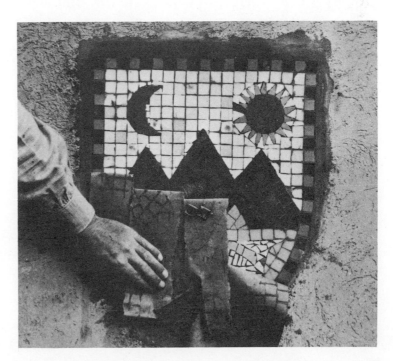

The covering paper is
soaked off after a few days
when the mortar has
hardened.

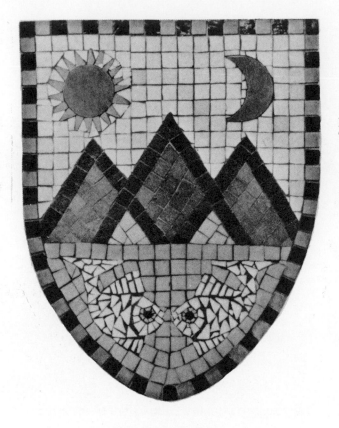

Here is the completed coat-of-arms. The final step is to fill the joints with extra mortar where necessary.

procedure. The letters or numbers on the back of the paper serve as aids in accurately reassembling the mosaic. Additional joint mortar can be trowelled onto the stone side of the mosaic sections and placed directly on the support base or wall with them.

Level off the surfaces of the stones by running over them with a piece of board and pounding lightly with a mallet where necessary. Let the mortar set for a few days. Remove the paper with water, clean the joints and fill in with extra mortar where necessary. Finally, apply a coat of paste wax.

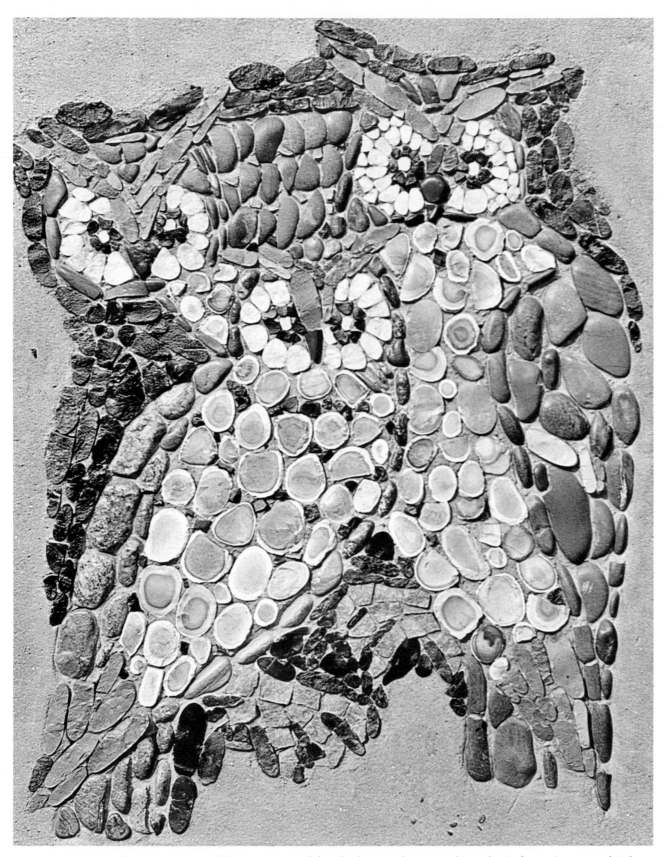

For these three owls, some pieces of jasper were used for the breasts, but everything else is from river gravel. The background is scraped joint mortar.

E

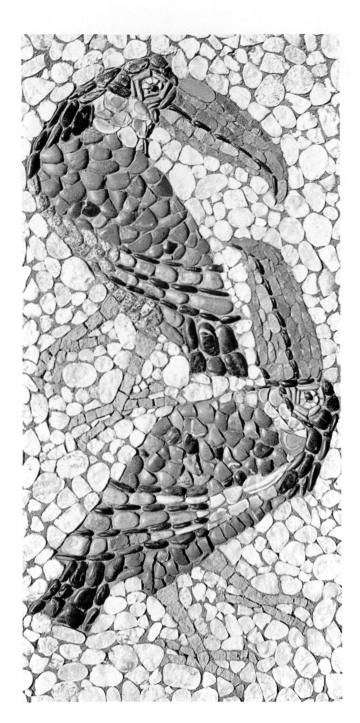

In the design of this mosaic, the bodies of the two toucan birds are divided by the diagonal placement. The subjects are related by the beaks that are turned toward one another and by the pupils being set forward in the eye sockets.

Indirect Setting

This method is the easiest for working with natural stones because the stones are always face-side-up while the mosaic is being arranged and the face surfaces of thick and thin stones are all at the same level and corrections can be made easily as the project progresses. It is believed that the craftsmen of Rome and Ravenna used this technique centuries ago. It is employed today by archeologists who glue fabric to newly-discovered floor and wall mosaics, loosen them from their base materials and transfer them to a portable slab.

With this method, you temporarily press the stones face up into a non-hardening substitute setting medium such as Plasticine, clay, wet sand or

Spread a thin layer of clay over your setting board.

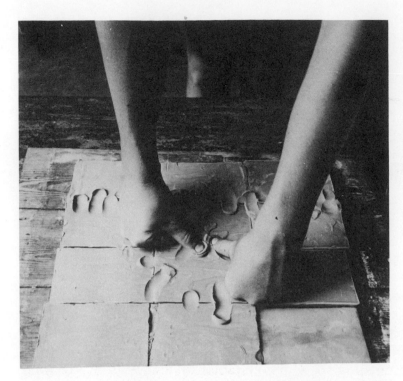

Use your thumbs to close up the cracks between the blocks.

earth. When the arrangement is complete, you glue a cloth to the surface to hold each stone in its proper place, then turn the whole work over as a unit. Next, remove the temporary setting medium and, from the back side, pour the permanent mortar in between the stones. Finally, remove the cloth and clean and finish the surface as explained in the following step-by-step directions:

Step 1. Plasticine or modelling clay comes in blocks which have to be cut with a knife into slices $\frac{3}{8}$ inch (1 cm.) thick. Lay the slices out side by side on a plastic or oilcloth covered composing board. Close up the cracks between the slices by pushing clay from one slab to the other with your thumb. By pounding the clay with a broad-headed mallet and then rolling it out with a rolling pin or scraping it with the edge of a 1″ × 2″ piece of board, you can quickly level off the surface. Cut off any irregular edges with a spatula and put the extra material aside since you will need it later.

Plasticine has two small disadvantages to watch out for. White marble absorbs oil out of it, turning grey. To prevent this, moisten the pieces of marble with waterglass (a solution of sodium silicate) before starting. Alternatively, draw the oil out of the Plasticine by pressing it for several days under frequent changes of newspaper. The second problem is that fresh Plasticine is excessively sticky. You can overcome this by sprinkling the surface sparingly with powdered pumice. Otherwise, you may have trouble later on in freeing the Plasticine from the stones. The adhesive quality of the Plasticine diminishes as you use it, vanishing completely after about five mosaics.

You can also use blocks of ordinary clay as a temporary setting medium but this dries up so quickly that you will have to cover it with wet cloths and plastic sheeting after each work session.

Step 2. Transfer your design to the Plasticine or clay using a perforating wheel or sharp stick as described earlier.

Step 3. Begin placing stones just as in direct setting. Lay the stones side by side with a minimum space of about $\frac{1}{16}$ inch (1-2 mm.) between them. Press the stones face up into the Plasticine but just deeply enough to hold them securely and never more than one-third of their thickness. When you come to a stone that is substantially thinner than the rest, underlay it with a small amount of extra Plasticine so that the surfaces of all the

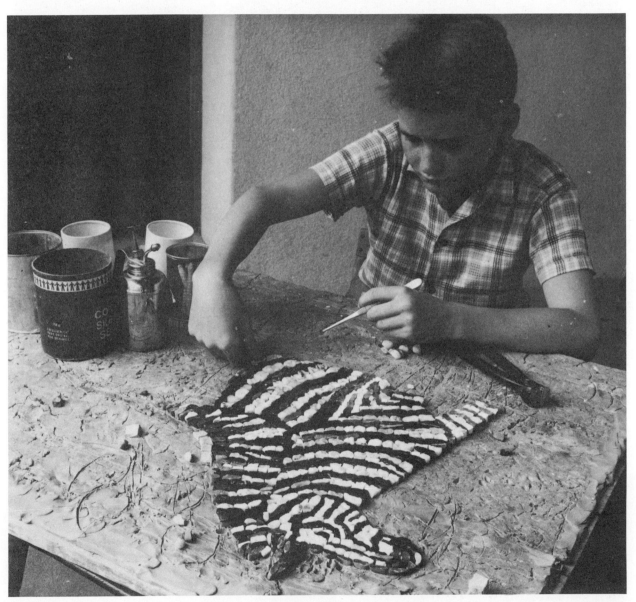

Trace the outline of your design directly into the clay, then place the stones one at a time, cutting them if necessary as you proceed.

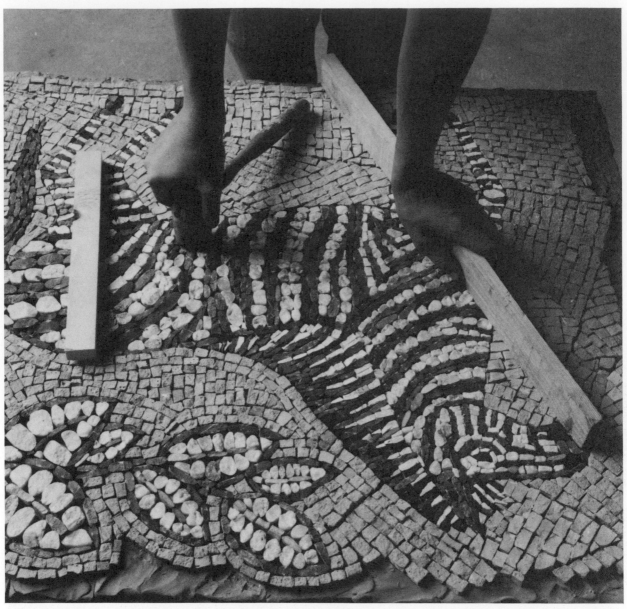

Level off the surface of your mosaic as you go. Use a straight piece of wood to press individual stones down so their surface is just even with the others.

stones remain at the same level. Thicker stones have to be pressed in more deeply and, if they are very thick, you may have to cut away a little Plasticine to make room. Since Plasticine retains its pliability, you are able to take your time and make changes or corrections in the design as you wish. Remove any stones that are too prominent or not just the right shade and replace them with others that are more appropriate.

From time to time, dampen the surface of the mosaic as you work. This brings out the true brilliance of the stones' coloration as they will appear when finally finished, allowing you to judge accurately the effect of the completed work.

Step 4. To level off the surface, use a large board. Since Plasticine offers firm resistance, work on just one area at a time. Use a wooden mallet or a piece of 1″ × 2″ to hammer down any stubborn stones.

Step 5. Correct any slight misplacement of stones by shifting them with your tweezers or fingers but without lifting them from the bedding material.

Step 6. When all of the stones are in place, build up a low wall of Plasticine around the outermost row of stones to prevent their being tilted or twisted during the following steps.

Step 7. Prepare the melted dry glue in its water bath or double boiler (see page 37). Lay a porous piece of burlap (hessian) over the surface of the mosaic, covering it completely. Smooth the burlap out flat and brush glue over the surface. Working in vertical or horizontal bands, press the brush down and dab and pound the surface with it. This brings the burlap into close contact with the stones. The glue will penetrate the mesh and pores of the burlap as you work with it. Do not use glue that is too thick or only lukewarm as it will not penetrate the cloth. Above all, do not use too much glue. A 1/64th inch (1/3 mm.) layer is just as good as a much thicker layer.

A variation is possible when the mosaic consists of small, close-fitting stones with smooth, level face surfaces. In place of the porous burlap, use a piece of worn-out bedsheet. Brush it twice sparingly with fish glue, mucilage or something similar and lay it loosely over the face of the stones. The cloth needs to be able to stretch a bit in order to take hold of any deeper-lying or slanting stones. Press the cloth down with a sponge.

When all of the stones are in place, glue a piece of burlap (hessian) over the surface.

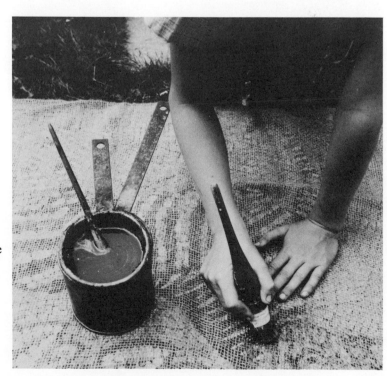

You needn't be discouraged by so many do's and don'ts. Actually, working on a mosaic is less complicated than it is to describe the procedure.

Step 8. Let the glue dry overnight. If you are impatient, you can speed up the drying process with an electric hair dryer. Fan the layer of glue with a stream of warm air until it feels dry to the hand (usually about half an hour).

If you are doing a relief mosaic with some stones deliberately projecting above others, pay careful attention while applying the glue so that the cloth gets down into all the crevices. Otherwise, stones can be detached easily when you remove the temporary setting medium.

Step 9. Lay a cover board on top of the cloth-covered mosaic and turn the entire assembly over. If the mosaic is small, you can turn it easily. In the case of a heavy mosaic, use two C-clamps to prevent shifting and ask a friend for assistance. At this point your mosaic will look something like a sandwich with the cover board you used for turning at the bottom, the composing board on the top with a layer of stones and Plasticine in between.

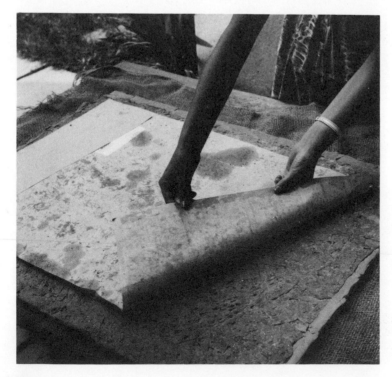

Turn the mosaic face down and pull the plastic sheet away from the back of the clay.

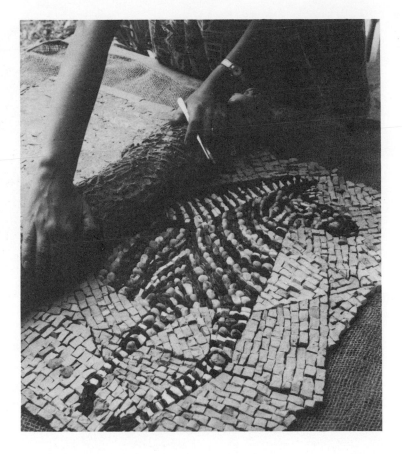

Next, roll the clay away, exposing the back side of the stones.

Step 10. Now lift off the composing board that served to support the Plasticine. Thanks to the plastic sheet that you put between it and the Plasticine, the board will not stick and can be lifted off easily. Roll away the plastic sheet by pulling it back and horizontally at the same time. If you were to pull straight up, you might also lift up part of the Plasticine and inadvertently pop out some of the stones.

Now you must roll the Plasticine off the stones, maintaining a careful watch along the line of separation between the loosening medium and the stones. If a stone lifts up with the Plasticine, remove it with tongs and put it back in place face down on the burlap. The back side of the mosaic is now exposed.

Step 11. Use a toothpick or an awl to remove any remaining bits of Plasticine from the backs or sides of the stones. Secure any loose stones by picking them up, wiping them on the glue brush and replacing them.

Step 12. At this stage, the mosaic can be moved, rolled or transported so long as the glue is not completely hardened. To what will you move it? Any flat surface which does not buckle up when wet and that won't be spoiled if you get a little mortar on it, but can serve as a concreting base. A concrete floor, the patio, an old lithographic stone, the marble slab of a discarded wash table will all do. A thick sheet of plywood or a thin sheet with a support frame underneath it will also serve but should be covered with plastic sheeting to prevent warping.

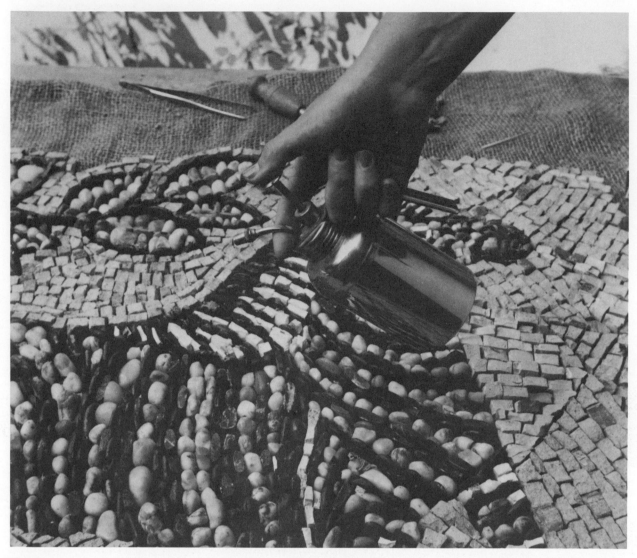

The first step towards adding the concrete base is to lay the mosaic, still attached to the burlap, on a solid surface with the back side of the stones facing up. If the cloth has buckled, dampen it with a fine spray. After a few minutes, the cloth will be flexible enough for you to flatten it out.

Step 13. When the mosaic is spread out, press down on the back of the stones to test whether the cloth is lying flat or has buckled. Buckling often occurs when the glue has been left to dry for a long time. If the burlap has buckled, spray some water on it with a small atomizer or wet with a damp sponge. After about 15 minutes, the glue should turn soft and the weight of the stones will flatten the cloth. In stubborn cases, repeat the dampening. The moistened cloth should be flexible so that you obtain a perfectly level surface when you press the stones against the base support with a sponge.

Step 14. Place a previously prepared wooden frame around the mosaic and fasten it securely in place. Use nails near the corner if you are working on a wooden support base. Otherwise, hold the frame down with any kind of weight.

Do you plan to remove the frame when the mosaic is completed? If so, wax or oil the inside of the frame and it will loosen by itself as the mortar dries. If you choose to leave it in place, however, then drive nails into the wood at about 6 inch (15 cm.) intervals so that they extend an inch or so (2 to 3 cm.) from the inner sides of the frame. The nails will become embedded in the mortar. Even if you use nails, you will still be able to remove the frame later. Just saw it into pieces and pull them away one at a time.

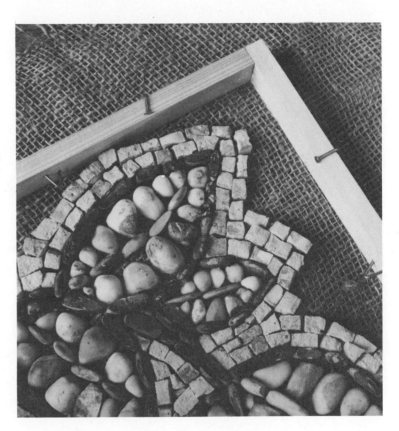

Drive some nails through the frame so that they will be embedded in the mortar when it dries.

Step 15. If your mosaic is going to have a field of mortar between the outside row of stones and the wooden frame, pull the burlap under the frame, stretching it away from the stones. Tack the burlap with thumbtacks or glue it (without wrinkles) to the work base. The burlap will impart a rough texture to the surface of the exposed mortar. Be sure to smooth out any wrinkles in the cloth, however, or they will be reproduced in the mortar. If you prefer a smooth surface, cut the fabric away along the outermost layer of stones. Your work surface then must be some smooth material such as sheet metal or plastic laminate.

In place of joints completely filled with mortar, you can obtain the nice play of shadows that comes from partially filled joints. To achieve this, use a salt shaker or a tea strainer to sprinkle fine sand into the spaces between

(Left) Stretch the cloth to remove any wrinkles and use thumb tacks to attach it to the wooden base.

(Below) A mosaic of this size needs to have reinforcement rods through the concrete base.

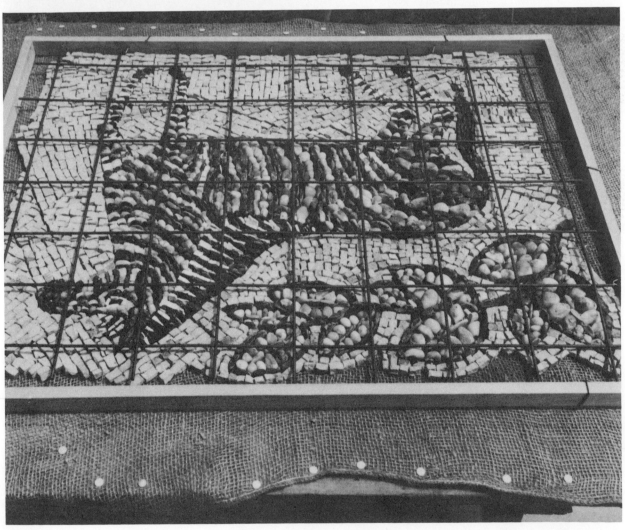

the stones to keep the mortar out. Do not let the depth of the sand exceed more than a third the thickness of the stone.

Step 16. Your mosaic will need to be reinforced with steel rods. Lay the armature inside the frame, directly against the stones. Be sure that the rods lie flat and do not rock. For ease of mounting the mosaic later, fasten a hanging wire to one of the rods. Be sure to attach the wire near the top edge.

Step 17. Pour joint mortar over the backs of the stones, lightly covering the entire mosaic. Work the mortar thoroughly into the spaces between the stones by jiggling and shaking the base. You can hammer and pound a bit too, if your support is solid enough.

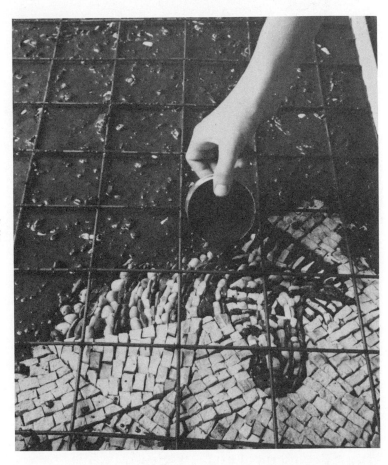

Pour joint mortar carefully over the back so that all of the spaces between the stones are filled.

Step 18. For mosaics with sections of exposed mortar, pour joint mortar first into these areas to the depth of the adjoining stones and allow it to dry for half an hour before proceeding. This will prevent the heavier mixture that follows from trickling or oozing through to the surface.

Step 19. Fill the frame with concrete (formula on page 36), distributing it evenly. Take into account the fact that in the pounding down that follows, the mortar will become more compact and settle as much as $\frac{3}{8}$ in. (1 cm.).

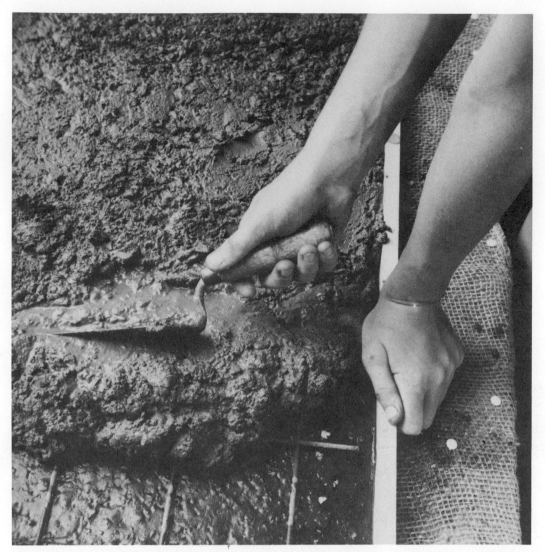

When the joint mortar has dried for half an hour or so, fill the frame with concrete, spreading it with a trowel.

Step 20. Pound the bed of cement with a trowel or piece of board until water rises to the surface. Pound especially hard near the edges of the frame.

Step 21. Rest the ends of a board on the top edges of the frame and run it back and forth to level off the surface of the concrete. Fill in any low places with extra material. Leave the surface fairly rough rather than making it glassy smooth, since you may sometime want to set the mosaic into a wall and a textured surface will make it adhere better. If you are definitely planning to set the mosaic into a wall, scratch a cross-hatch design into the back after the concrete has dried for 2 to 3 hours. At the same time, you may want to sign your name and write the date in the cement.

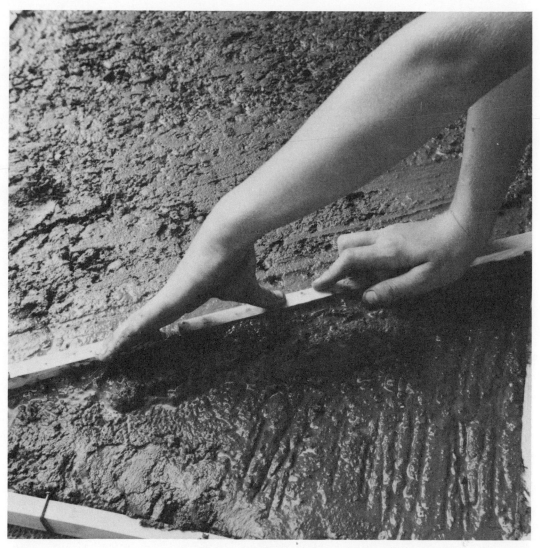

Rest a board on the top edges of the frame and run it back and forth to level the surface of the concrete.

After 2 to 4 days, depending on the season and the room temperature, you can proceed to the unveiling. Will the finished work correspond exactly to what you covered up with burlap and glue? Accidents and mishaps rarely occur, but now and again a single stone will have worked itself out of place. Let it have its way!

Finishing Consists of the Following Work:

Step 22. Use nippers or a claw hammer to pull out the nails holding down the frame or, as the case may be, lift off the weights.

Step 23. With a strong pull, loosen the mosaic from the concreting board and turn it over. If a pull doesn't dislodge it, pound on the support from underneath or along the edges. In extremely stubborn cases, push a

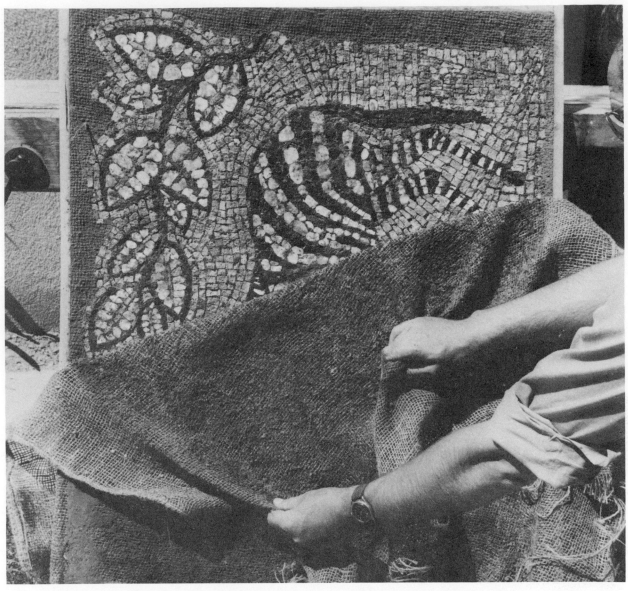

After the concrete has dried for a few days, pull the burlap away to unveil the finished mosaic. If the burlap does not let go easily, moisten it and wait for 15 minutes before trying again.

chisel or heavy screwdriver under one corner of the frame and lift it up. Pry carefully, however, or you will risk a broken-off corner.

Step 24. Pull the burlap off without hesitation, as you would remove an adhesive plaster. It should pull loose easily, since the glue will have become moist from contact with the wet concrete. If for any reason you have to wait for several days before removing the cloth, you should wet it thoroughly first and wait about 15 minutes before attempting to remove it.

Step 25. Stand the mosaic up at an angle and clean it with a stiff-bristled brush and hot water until all trace of the glue has been removed.

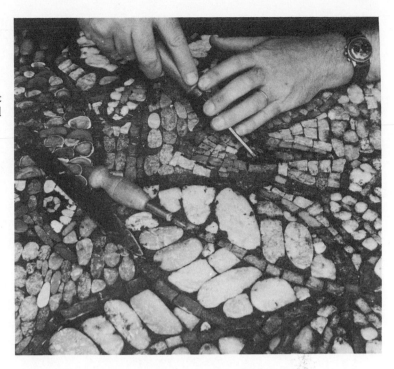

Finally, clean the face of the mosaic and scrape out the joints if they have filled in too much.

Step 26. Clean out the joints and, if necessary, fill them in with more joint mortar. For mosaics made with uncut stones, scrape out the mortar so that the full width of the stone is exposed. Any concrete areas without stones that you have left as an edging will show the attractive, transferred weave of the burlap.

Step 27. Certain stones, especially uncut white ones, tend to lose the freshness of their color. If this happens, brush them with hydrochloric (muriatic) acid. The appearance of foam indicates that the thin, outside layer of weathered rock is being dissolved. If, on the contrary, the glitter of glassy stones disturbs you, brush them with hydrofluoric acid, which etches the surface and gives them a matte finish. Use acid with a great deal of caution. Wear goggles and rubber gloves to protect your eyes and skin.

Step 28. Give the surface a hearty brushing once again with hot water to remove any remaining trace of the joint cleaning or acid application.

Step 29. Let the mosaic dry for an hour, then smooth down the frame with sandpaper, fill the nail holes with paste wood filler and apply a finish coat of paint or varnish.

That is the entire procedure, seeming perhaps a bit complicated at first glance, but really a logical sequence of steps. The total time required is probably a third less than that needed for direct setting, but the essential part of the work—the arrangement of the composition—goes incomparably faster. Once you have a finished mosaic behind you for the first time, you will be anxious to use the technique again.

To create a free-form mosaic without the fixed frame as prescribed for Step 14, build up instead an enclosing wall of Plasticine or clay to the desired height. This wall will do the same work as a wooden frame but is more flexible in regard to shape. Press the Plasticine firmly in place on the support board so that it cannot shift about.

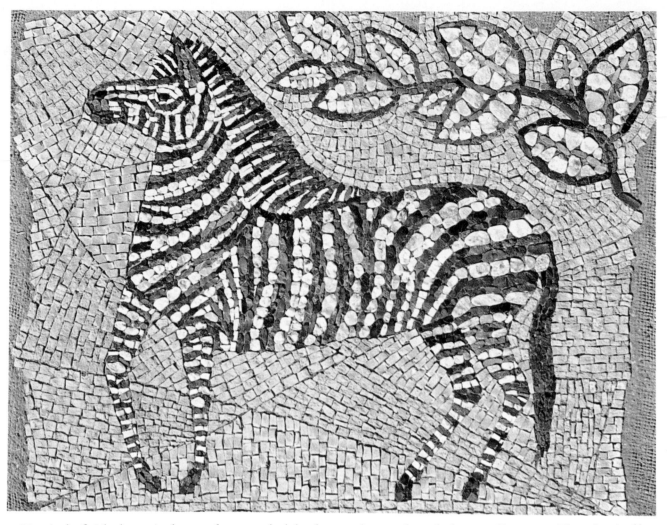

Here is the finished mosaic that you have watched develop step by step through the preceding pages. The zebra itself is made of split pebbles, and the background consists of pieces of yellow colored-cement. The feeling of rhythmic movement in the background was created by laying the stones in different directions. The branch at top right serves as a space filler but also gives the impression of a natural landscape.

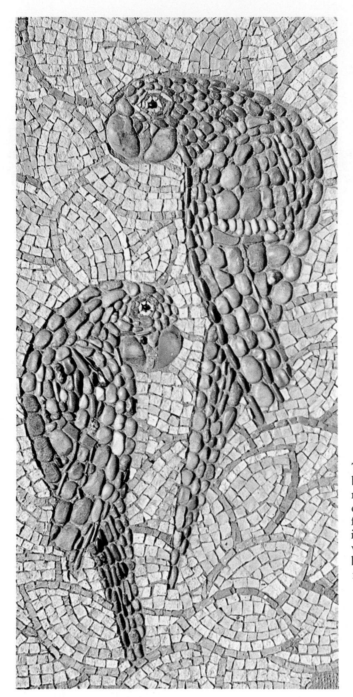

This mosaic of parrots on a
background of stylized leaves was
made largely from man-made
colored-cement stones mixed with a
few pebbles. The entire background
is made of pieces of colored-cement
while the blue stones were rolled
between the palms of the hands
from cement dough.

Displaying, Preserving and Restoring Mosaics

The best placement for any concreted mosaic is to embed it in a wall. There, it no longer is a work by itself but becomes part of the architecture. Whereas it was previously a mere decoration, it becomes an immovable thing, an inseparable part of the building.

Walls finished with a lime wash or light-painted plaster are most suitable for showing a mosaic to its best advantage. A bright, dominating

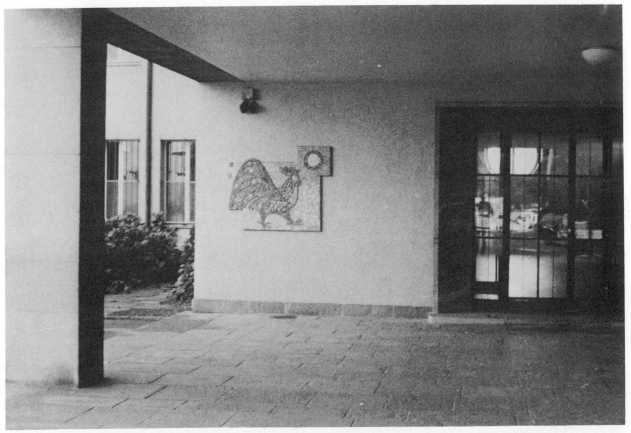

A large natural-stone mosaic is displayed to best advantage when it is mounted directly into a wall.

area in an entrance, vestibule or covered patio generally affords a good distance for viewing. The mosaic must be the principal point of interest and the surrounding décor must be subordinate to it to achieve harmony.

The white of a lime wash is certainly a suitable surrounding color but light grey, ecru, beige and paints of similar tone go well with mosaics of tasteful coloration. Bright-colored paints must absolutely be avoided because they make the mosaic seem as if it has no color at all.

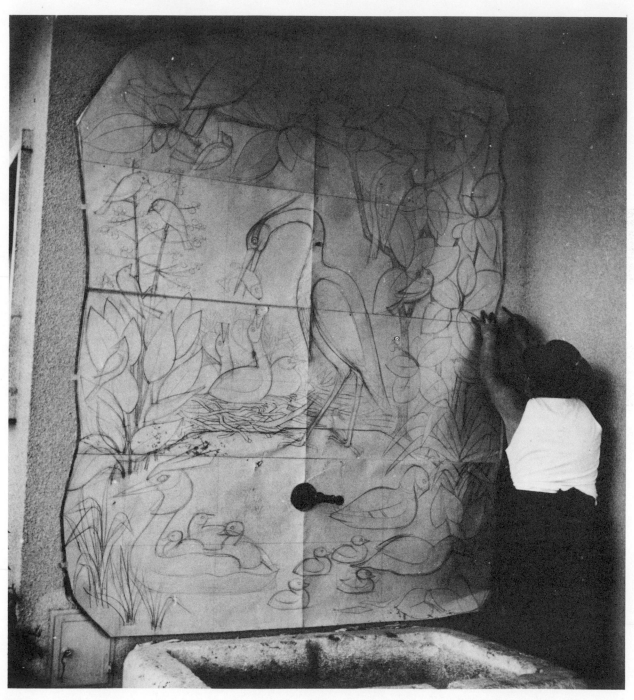

Wall Mounting a Single Slab

Step 1. To determine the proper place for a mosaic, use a piece of cardboard of the same size or a tracing of the mosaic and move it about on the wall until it looks right. Draw an outline around it with a pencil to mark the location. Draw a second outline about ½ inch (about 1 cm.) outside the first.

The first steps to embed a mosaic in a wall are to draw a line around the outside edge of the cartoon (opposite page) and then cut a niche into this area (right).

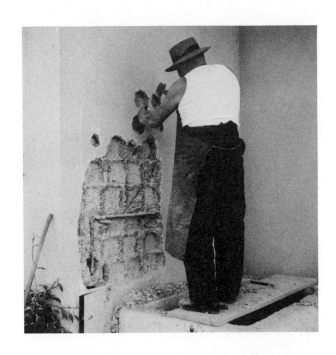

Step 2. Use a hammer and chisel to cut a niche into the wall as deep as the thickness of the slab over the area of the outside outline.

Step 3. Remove the wooden frame from the mosaic. If there are any rough edges, grind them smooth with a piece of sandstone or a carborundum stone.

Step 4. Set the mosaic into the wall so that its face is even with the wall surface, stands out about ⅜ inch (1 cm.) from the wall, or is sunk about ⅜-¾ inch (1-2 cm.) below the surface. The projecting presentation is not especially attractive in itself but it is a way to give the work extra emphasis. The same is true of set-in slabs, but, by cross-hatching the sloped plaster surrounding the mosaic, you can create the effect of a deep picture frame.

Use wooden wedges around the mosaic slab to position it accurately in its recess. For the final anchoring, hammer small pieces of tile or flat stone rather deeply into the spaces around the slab every 8 inches (20 cm.) or so. Be sure to remove the wooden wedges.

67

Step 5. Cover the mosaic with sheet plastic or wrapping paper which you can attach with paint masking tape.

Step 6. Moisten the spaces between the mosaic slab and the wall and fill it in with cement mortar made with fine sand. Press as much mortar in as you can. If you use a plastic bucket to hold the mortar and place it directly below where you are working at the moment, it will not only keep the mortar within easy reach but also will catch those bits that fall off as you work.

Step 7. Remove the protective paper and clean the mosaic and surrounding area with a damp sponge. After they are dry, the cement-colored joints are not unpleasant. Although they will surely be at least a shade different than the surrounding wall even if it is cement also, attempting to match the colors exactly is seldom successful.

Mounting a Wall Mosaic in Multiple Slabs

Due to the obvious problems of weight and maneuverability, larger mosaics must be constructed in sections of manageable size—generally about ½ square yard (½ square metre)—which are then assembled right on the wall. Mounting these sections differs from the procedure already described for single slabs in the following particulars:

Step 1. Chisel the niche in the wall as deep as the thickness of the slabs plus an additional ¾ inch (2 cm.).

Step 2. Set the bottom row of sections into the wall, wedge them in place and brace them with boards or laths. Fill the joints with cement mortar.

Step 3. Using a square-ended scoop shovel, pour a fine-grained, semi-fluid concrete down behind the slabs, filling the space right up to the top edge of the slabs. Here is the reason for bracing the slabs with boards—the weight of the concrete behind the slabs would otherwise force them right out of the wall. Let the concrete set for 2 to 4 days.

Step 4. Take away the bracing and install the next row of slabs as in Steps 2 and 3 above. Pouring mortar behind the top row of slabs offers difficulties because the last joint at the top is comparatively narrow. You can facilitate this job by (a) chiseling out a somewhat taller niche in the wall, resulting in a wider joint at the top, (b) by sloping off the upper edge of the slabs with a chisel so they slant diagonally downward toward the back or (c) by leaving off some of the last part of the mosaic along the top edges of the slabs and do this part by the direct setting method after the slabs are installed.

With this technique, you must decide at the very beginning of the project whether to allow the joints to remain visible as squares—the easier, less elegant solution—or to close them up to make them invisible, a task which makes greater demands for the final treatment. Visible joints of more than ⅜ inch (1 cm.) leave something to be desired, regardless of whether they show up as a network of rectangles or follow the contours of

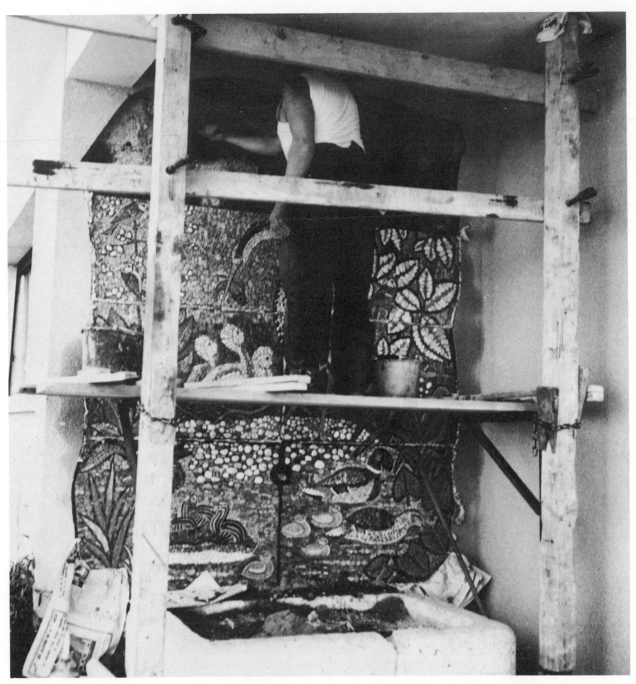

Large mosaics must be constructed in sections. These are then set into the wall, working up from the bottom. The slabs must be braced with boards to hold them in place until the mortar dries.

the design. Either way, you have the effect of the mosaic having been cut up with an oversize carving knife and the whole thing looks as if your planning did not extend as far as the completion of the work. The harmony of the work is broken down into bits and pieces, just like the work itself.

Visible Joints

Divide the cartoon into parts which may be square or rectangular but should all be the same size. In doing this, take care that the cuts marking the divisions do not run through faces and areas rich in detail. Make a tracing on translucent paper for each piece.

In the setting of each section, you must strictly observe the borders of each. Do not set part 2 without having part 1 next to it, etc. You will thus avoid the mistake of setting continuing rows of stones in divergent directions. While working on adjoining sections, place a small piece of plasterboard or wooden lath on edge between them, corresponding to the width of the joint that has to be figured in.

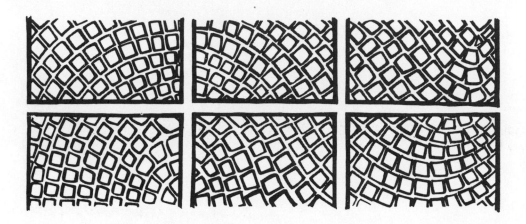

When you have completed the setting of the section next to section 1, you can go ahead with concreting section 1. After you have finished with section 3, you can concrete section 2, etc. Be very careful with the measurements for the wooden concreting frame. For all of the sections to fit together smoothly, the frame must have perfectly square corners. You can check this by measuring the two diagonals of the frame. If they are of equal length, you can expect a slab with accurately right-angled corners. To assure a level surface, you must have a level support board for the concreting and the four corners of the frame must be fastened down to it. For a really large mosaic that must be divided into many sections, an angle-iron frame will hold up better.

Invisible Joints by Direct Setting after Mounting

Make a tracing of the cartoon as above, but divide the sections with a zigzag cut $\frac{3}{8}$ to $\frac{3}{4}$ inch wide (1 to 2 cm.). Use cement-lime mortar to mount the sections, but fill in only the outside joints before pouring concrete behind the slabs. Caulk the inner joints temporarily with tarred rope (oakum) or rolls of paper. After the cement poured behind has set, remove the caulking, chisel the mortar out of the joints up to the edges of the mosaic stones, then fill in the space with mortar and stones using the direct setting method.

Joints between sections can be concealed by hand-setting small stones directly into the joining mortar.

Mounting without Joints

Use the indirect method of setting, placing stones in a temporary setting medium. Any edges that will be part of the outside edge of the complete mosaic should be kept perfectly straight by lining them up against pieces of wood. Edges of the section that will touch against other sections of the mosaic can be free-form. Build up an enclosing wall of Plasticine or clay for these sides before pouring concrete over the back of the stones.

Set the next section with the first section lying alongside for reference. Raise it up to the same level by sliding some boards underneath the Plasticine. Use the finished, right-hand edge of section 1 as the form for

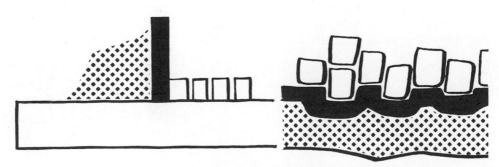

In making the frame in which to pour concrete over the back of a mosaic section, use boards for straight-line edges, a wall of clay for free-form edges.

Here is the completed mosaic installed in a wall with a fountain extending from it. See the preliminary sketches and full-size cartoon on page 26, details of the design on the opposite page.

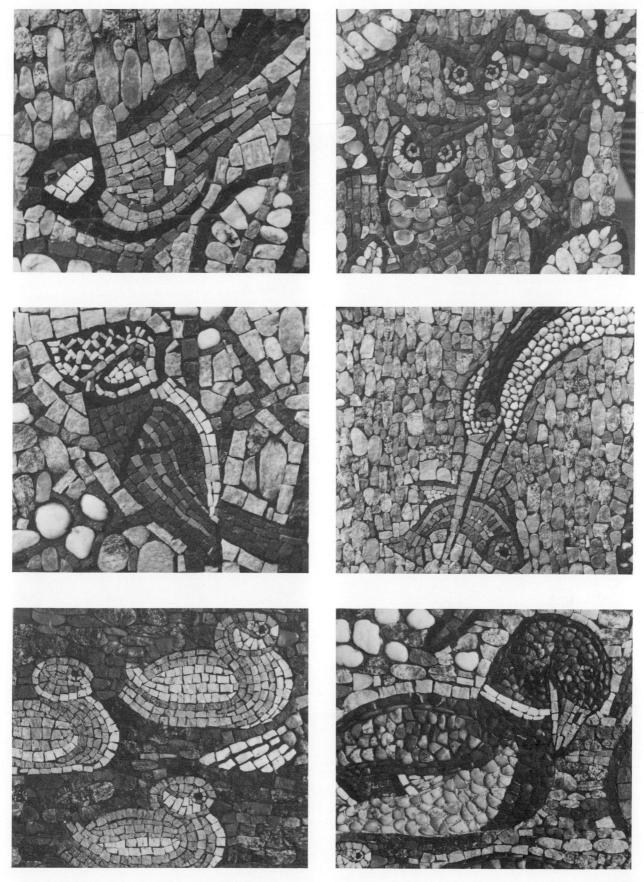

the left-hand edge of section 2 (oil it, otherwise the new mortar will adhere). Again, use wood strips for the edges that need to be ruler-straight, and use clay or Plasticine for the remaining sides. The minute, tight fitting involved requires a great deal of time and patience.

Matching up inside edges of mosaic sections.

For a mosaic covering an area of 1 to 2 square yards (metres), you can use a variation on this method. As the mosaic is being assembled, divide it into sections by inserting sheet-lead strips (oiled) about 1¼ inches (about 3 cm.) high between the stone slabs. Brace the strips upright by pouring concrete in on both sides first, then fill in the rest and finish the surface. The advantage of this technique is that the various sections fit together accurately and easily without supplementary work. This is offset somewhat by the need for a large amount of setting medium, heavy slabs and more difficult work in placing the mosaic stones.

Use flexible metal strips as dividers between sections.

The absolutely accurate fit of the slab sections obtained with either technique does allow for speedy mounting and finishing. The last step is to brush joint mortar into the almost invisible spaces. There is, of course, no internal adhesive bond between the edges of the sections, but the downward pressure of the weight and the adhesion of the cement from behind is quite sufficient to hold the assembled mosaic securely.

Table Mosaics

To change an old, slab-top table to a mosaic-covered table is not a difficult task. The only requirements are that the table have solid legs and a strong, one-piece top rather than individual leaves. The mosaic slabs have to be glued directly to the table top. Modern chemistry has produced several glues and cements that will bond stone to wood. However, if you make the mosaic to the exact dimensions of the table, you can attach a wooden strip to the edge of the table to serve as a border and hold the mosaic down.

Another possibility is to make the mosaic so that it slightly overhangs the table top and then you can grind it down to the exact size and shape of the base. If the mosaic is to last for years without the stones coming loose, the mosaic slabs have to be just as massive as if they were to be set in a wall and the support frame of the table must be correspondingly solid. With any slab thickness of less than ¾ of an inch (2 cm.), you run the risk of breakage, which means, unfortunately, that natural stone mosaics are just not suitable coverings for small tea tables.

Unsplit, natural stone is generally used for outdoor gardening tables, while polishing is almost obligatory for indoor tables. The edges of mosaic stones that will be visible should be cleaned up with a carborundum wheel before mounting. Polished surfaces do not correspond with fast work. Using thinner stones will enable you to produce lighter weight mosaic slabs, while still achieving the smooth surface required for a satisfactory table top. Use the indirect setting method.

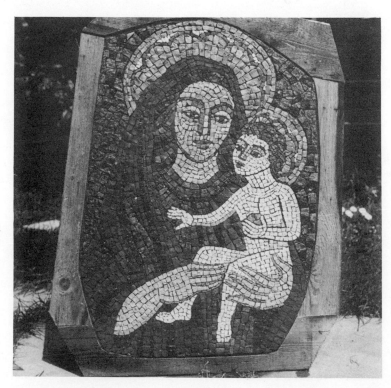

The unusual, rough-hewn frame sets off this mosaic of the Madonna and Child.

Preserving Your Mosaics

Rain, ice, snow and sun are enemies of natural stone mosaics on uncovered, outdoor façades. Stone tends to turn grey from exposure and freezing weather leads to cracks and loosened edges. These effects cannot be overcome completely, but waterproofing with a clear plastic finish or a colorless sealer will put them off for a while. Further resistance to weathering can be developed for natural stone by grinding and polishing, although many craftsmen feel that this destroys or at least diminishes the beauty of the surface—the granular, often irregular faces of the individual stones complemented by the occasional roughness of the broken edges.

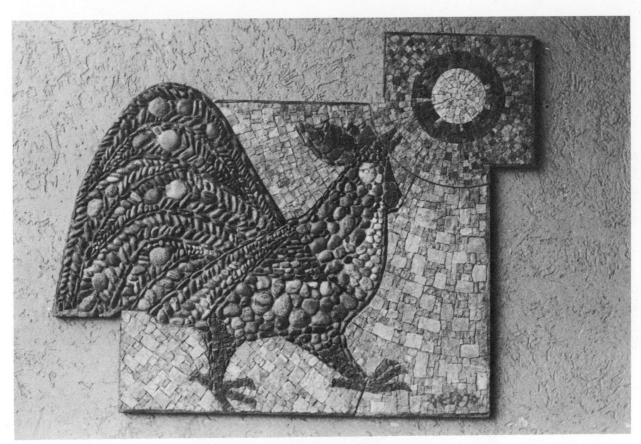

Here is a close-up view of the wall mosaic shown on page 65. Mosaics that are exposed to the weather should be coated with a clear sealer or a coat of wax.

Polishing Mosaics

While most natural stone mosaics are best when left in their rough form, a small mosaic, precisely cut and set in a masterly way, may sparkle among its rougher brothers like a faceted diamond among pebbles if its surface has been polished. Polishing should be an exception to the rule,

Though it is a time-consuming task, it is possible to polish the surface of a mosaic by hand, using grindstones and carborundum stones.

an unnecessary but charming luxury. It does have the indisputable virtue of permitting the various colors to break forth in shining beauty when they do not have to compete with the jagged edges of natural stone. For a mosaic composed of gem stones, polishing is absolutely obligatory.

Hand Grinding

This is a wearisome project. Even if you grind an hour every day, it may take you a year to finish a large job. Even a small mosaic requires 10 hours of hand grinding to achieve the same result produced by a quarter-hour of machine grinding. Nevertheless, for those with endless patience, here is the procedure.

Grind with vertical, horizontal, and circular movements.

An electric polishing
machine reduces the work
of hours to minutes.

Begin with a flat, hand-sized grindstone (sandstone) of about 2 lbs.
(1 kg.) weight. Pour water over the mosaic and repeat this step every now
and again. Alternate between grinding vertically, horizontally and in a
circle. As you work, a kind of mud gathers from the grinding. Wipe it
away from time to time with a sponge or flush it off with a stream of water
from a hose.

Change to a carborundum stone of medium grit and use it with pumice
powder also of medium grit. Finish off with fine pumice. It is not necessary
to produce a glasslike polish with polishing rouge or anything of that kind,
because you can get the same kind of polish with less work and trouble
simply by polishing with paste floor wax.

Polishing with an Angle-Head Polishing Machine

This is a handy tool designed for the stonecutting trade that turns at
about 1800 RPM. It is similar to an electric hand drill. The disc grinds at
a right-angle to the axis of the motor housing. Grinding discs of various
hardness are available. For the initial coarse grinding, use a disc of about
#120 grit. For the final, scratch-free polishing, use a disc of #200 grit or
finer. Carborundum grit can also be used with it. The grits are numbered
according to the number of meshes per inch through which the grit will
pass. Grits #8 through #40 are coarse grits, while anything over #100
is considered fine. The disc must be flat against the work, otherwise it will
chatter and slide about.

Grind dry and only in the open, or you will thoroughly coat your work
room with stone dust in a very short time. Don't attempt to shorten the
grinding time by bearing down on the machine. The increased friction
creates heat and many stones change color when subjected to heat. When
the machine is operating or even while it is slowing down after being

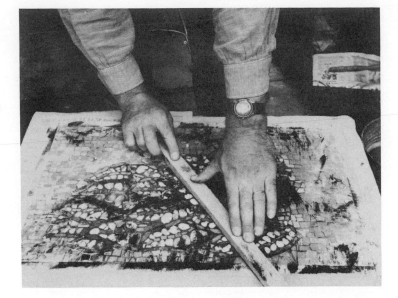

Use a piece of lumber to find any high spots on the mosaic surface.

switched off, hold it well away from yourself—one second against your body is enough to make a sizable hole in your clothing and may painfully scrape your skin. Wipe the stone dust from the surface of the mosaic from time to time. When you are finished, wet the surface, which will bring out any gaps or missed spots.

Professional stone polishers use a special guide to obtain perfectly level surfaces. An amateur craftsman, however, can make do by rubbing a straight piece of lumber dusted with powdered pigment over the mosaic. The color will stick to the high spots. Run the grinder once more over these high spots and then use the board again. After being worked over several times, the surface should be satisfactorily level.

Patches and Corrections

An experienced mosaicist as well as a beginner can make an error or suffer an occasional bit of bad luck. Often it is only after some time has elapsed that the craftsman discovers while standing at a distance from the finished work that some part could be improved upon or needs repair. It is the mark of a conscientious worker that he then uses the best of his ability to restore the mosaic to its optimum condition.

Resetting Stones

If a single stone falls out and the surrounding mortar remains intact, simply glue it back in place with some kind of universal cement. To reset a single poorly-chosen stone, chisel it out and deepen and enlarge the cavity right up to the edge of the adjacent stones. Wet with water, fill the cavity with joint mortar and set the new stone by the direct setting method. Follow the same procedure to reset an entire area.

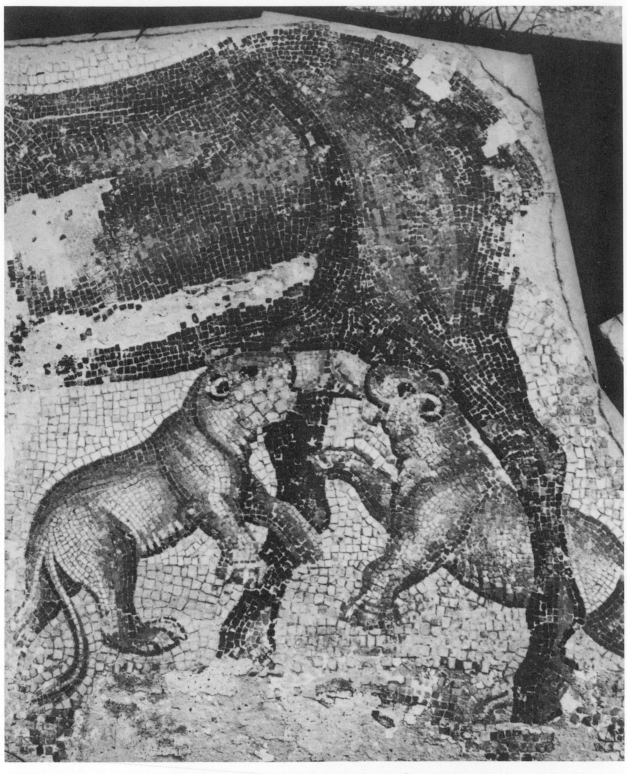

Here is a fragment of an ancient Roman mosaic before restoration. Earlier "improvements" included filling the missing areas with colored plaster of Paris and crudely replacing stones in the head of the left cub with too-large substitutes.

Restoring Mosaics

Where a mosaic has fallen to pieces, use the following procedure:

Step 1. Fit the broken pieces together, picture side up. Glue small bits of broken stones together with universal cement.

Step 2. Prepare a close-fitting, mortar-retaining frame that stands as high as the thickness of the mosaic plus $\frac{3}{4}$ inch (2 cm.).

Step 3. With a cover board as well as a support board, turn the mosaic over. Set the frame in place and attach it. Lay reinforcement on the back side of the mosaic.

Step 4. Spread fine concrete over the back of the mosaic right up to the top of the frame.

Step 5. When the cement has set, turn the mosaic right side up and chisel the mortar out of any empty areas to the depth of new stones ($\frac{3}{8}$ to $\frac{5}{8}$ inch—1 to $1\frac{1}{2}$ cm.). Put the new stones in place using the direct setting

This is a competently restored section of the Roman mosaic shown on the opposite page.

81

In restoration of damaged mosaics, new concrete backing is poured in over the back of the stones just as in the indirect method of setting.

method, allowing them to extend a tiny bit above the surface of the old stones.

Step 6. Grind down the new areas that stand out, using the right-angle sander-polisher or by hand with a carborundum stone. A time-saving possibility is to grind the face of each stone individually to start with and then set it in level with the rest.

Step 7. Clean out the joints with a pointed tool, then fill them all with clean colored-cement and finish.

In the case of a mosaic having been set in plaster instead of being cast in quality mortar, follow these steps:

Step 1. Working from the back side of the mosaic, carefully remove the plaster with chisel, awl, putty knife, etc. Blow away all of the loose dust and plaster chips using a short piece of garden hose held to your mouth. Replace immediately any stones that fall out, using hot liquid glue.

Step 2. Set a frame and reinforcement in place, fill in with joint mortar, then spread on the concrete ¾ to 1½ inches (2 to 4 cm.) thick, depending on the size of the mosaic. Let the mortar set.

Step 3. Turn the mosaic picture side up. Dig out any stones that have sunk below the surface, chisel out the surrounding concrete and reset the new stone or stones level with the rest. Grind any projecting stones or areas down to the general level. Any missing stones, of course, need to be replaced. The final step is to scratch the remains of any plaster out of all the joints and fill them in with cement.

To save space, mosaics are sometimes stored and sold with the pieces glued face down to cloth. The problem, especially if there are several sections or fragments involved, is that the restorer is unable to see the picture side since it is glued over with drill. To reassemble such a mosaic, proceed as follows:

Step 1. In drying, the glue often buckles the cloth so that differences of level of as much as 4 inches (10 cm.) may exist. You can flatten the cloth out by laying it face down on damp earth or a wetted soft insulation board and spraying water lightly over the back. Avoid too heavy an application of water, though, as the glue may soften and release the stones.

82

Step 2. Since every fragment of a mosaic has a different, usually irregular outline, using mass-produced frames is impossible. There is no other way out, then, than to fasten slats of wood ¾ inch (2 cm.) to the support board with nails at the corners.

Step 3. Fill in the back with joint mortar and soft concrete made of 6 parts sand, 2 parts cement and 1 part lime. Let the cement set, remove the glued-on cloth and clean up the face side. When each of the fragments has thus been prepared, it remains only to assemble the parts into a whole.

Step 4. Make up a full-size cartoon showing the fragments in their proper relation to one another. Trace the picture outlines through to the backside of the paper.

Step 5. Get everything ready for concreting. The supporting surface for large pieces should be a level concrete floor, never wood. Lay the cartoon on it, back side up, and lay the cast/slab fragments on the traced-through outlines. Any parts of the cartoon not covered by slabs need to be covered with clay, Plasticine or sand to a depth of ⅝ inch (1½ cm.). Lay a reinforcing armature in place within a frame, the height of which needs to equal the thickness of the laid-in slab pieces plus another ¾ inch (2 cm.) for the concrete strengthening.

Step 6. Do not use joint mortar at this stage! Fill in the frame with a concrete made up of 1 part cement and 2½ parts sand and fine gravel. Wet the fragments of the mosaic well before pouring the concrete. A new slab is thus formed when the concrete sets. It will be quite heavy but very strong.

Step 7. Dig out all the "blind spots" and fill them in with new stones using the direct setting method. Clean and fill the joints and, finally, grind and finish the surface.

In all restoration work, it is important not to patch, improve nor doctor any more than is absolutely necessary. The more you add, the less the restored work is likely to correspond to the spirit of the original. Many restorers of ancient mosaics prefer to fill in missing areas with plain cement rather than to guess at a reconstruction of the original. The best restorations are those in which the restorer himself cannot pick out the places where he has made his restorations.

A Gallery of Natural-Stone Mosaics

This ancient Roman mosaic of a hunting dog clearly shows the contour setting of the first rows of background stones.

Here is another Roman mosaic, with the stones set in tight little rows. The first two rows of the background stones follow the contour of the design while the balance are in horizontal rows.

This ornamental Roman mosaic is not as symmetrical as it seems. Each leaf is slightly different and the shape of the stones varies greatly.

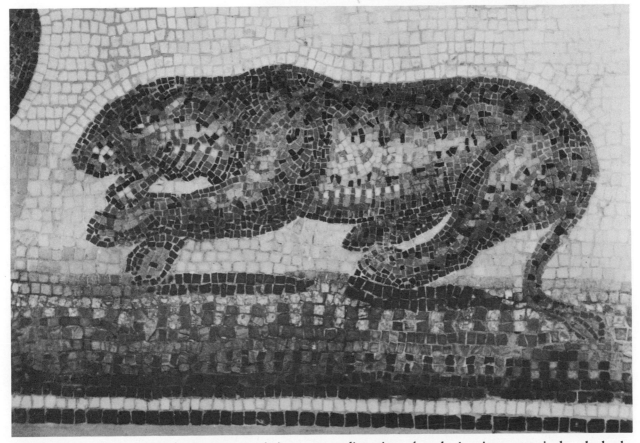

The panther in this segment of a Roman mosaic is an outstanding piece of work. A point to note is that the background is set in much larger (more quickly set) stones than the animal itself.

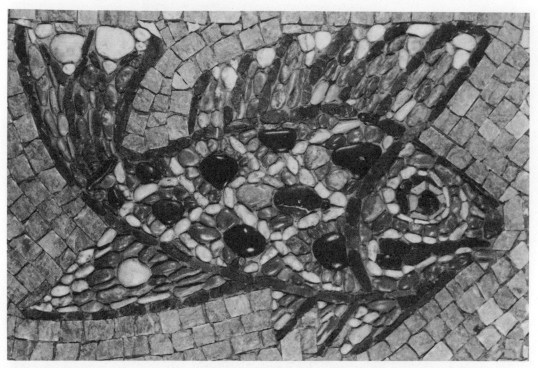

Yellow, black, and white stones form the body of this fish. The outline is made of pebble slices, the background of squared pieces of marble.

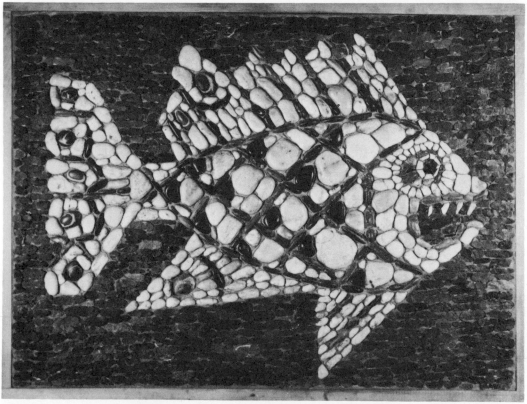

This sharp-toothed creature is more like a water dragon than a fish. The ornamental arrangement of the stones in its fins strengthens the unnatural effect.

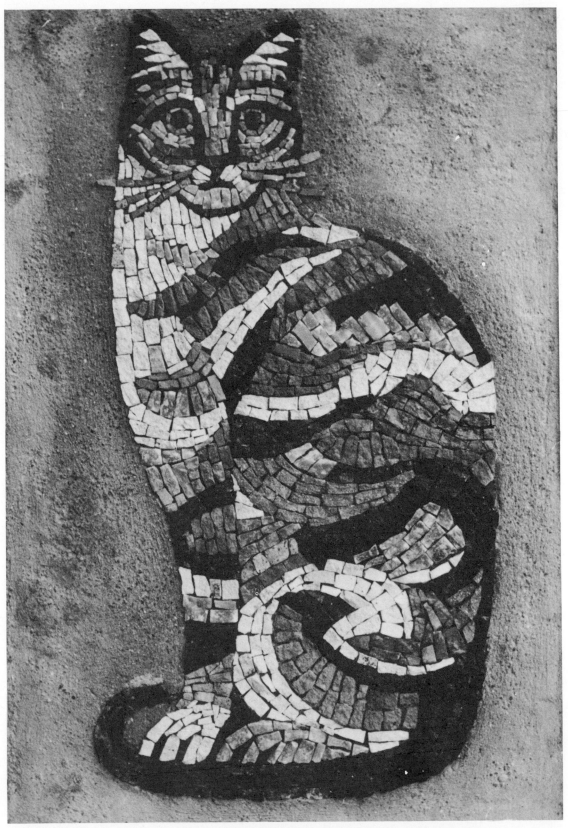

Made from a combination of natural stones and colored-cement pieces, the lively pattern of the stones in this mosaic contrasts nicely with the reposing form of the design.

For the indirect setting method, an outline of the design is traced into the temporary setting medium. Begin setting with the main features of the design.

The completed mosaic.

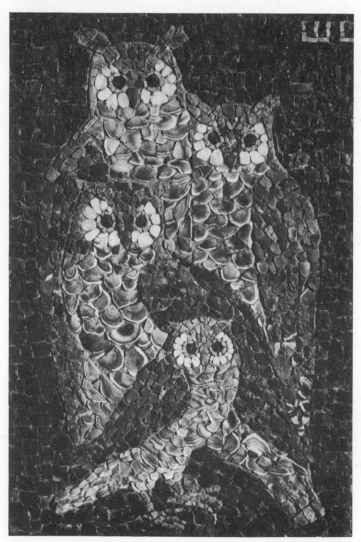

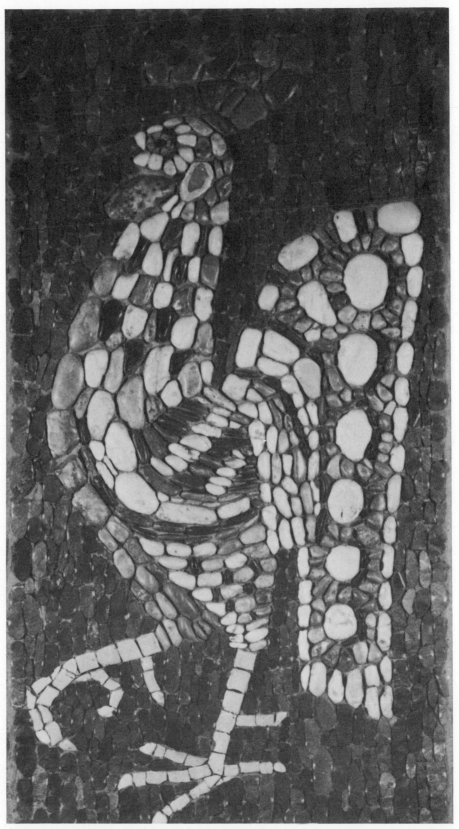

The proud bearing of this rooster is intensified by the tall, narrow format of the mosaic. Note how the two thighs are differentiated by running the stones in different directions.

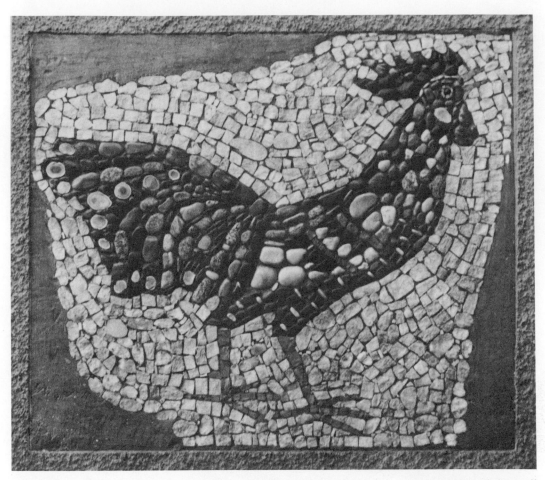

This mosaic of a crowing rooster has been set directly into a wall. The rough surface of the wall contrasts pleasantly with the smooth surface of the exposed mortar in the mosaic itself.

This kingfisher was created by the direct setting method, each stone placed directly into mortar spread over a concrete base.

Here is a small decorative mosaic with only mortar, no stones for a background.

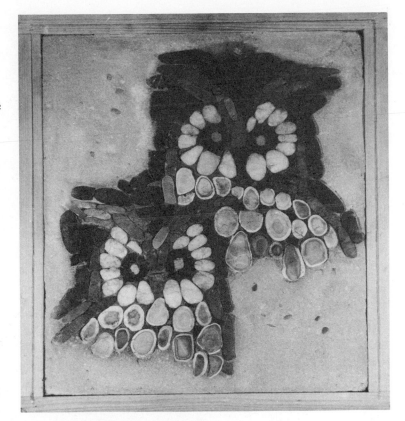

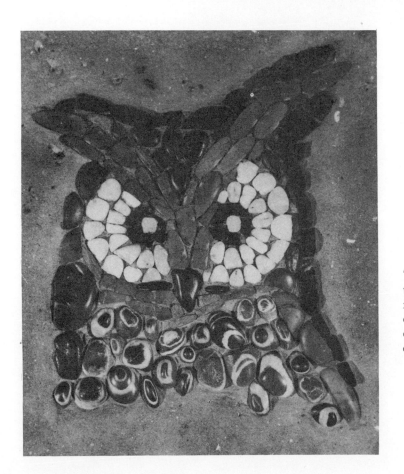

The coarse material above the owl's head has worked its way through the layer of joint mortar, the result of not letting it dry long enough before concreting.

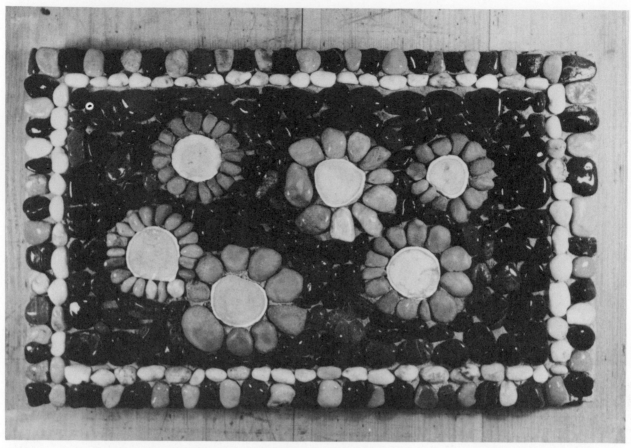

Here is a simple project using natural stones. Spread glue over a base board or tile, place your stones, then pour some sand over the front to cover any part of the base that would otherwise be visible between the stones.

The raised effect of this mosaic was created by cutting away some of the mortar before it dried.

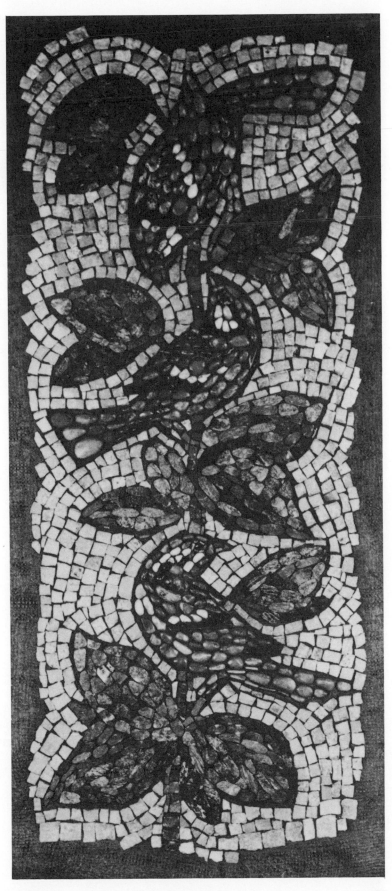

Many materials are combined in this mosaic—green granite for the leaves, limestone for the background, and imitation pebbles made of blue colored-cement for the birds.

These three humorous masks were made almost entirely from pebbles cut in half, with their split faces up. They were set directly into mortar and the remaining background surface was smoothed with a wooden float.

Note the herringbone pattern of the background stones in this mosaic.

94

INDEX